INYOURHEAD ENTERTAINMENT BOOKS

Present

CUTE LITTLE HOUSES

Adult Coloring Book

ART: Julius Arciniegas

DESIGN AND EDITION: Orlando Oliveros

Copyright © 2019 INYOURHEAD
All rights reserved.
ISBN: 9781695674905
Imprint: Independently published

PROLOGUE

The Lovers of coloring books say that colors make them feel calmer, mentally clearer, happier and more relaxed. When engaged in his hobby, his worries fade temporarily. Art itself has the characteristic of taking the brain to a stage of meditation; many experts have observed that it reduces levels of depression and stress. Coloring gives us that freedom to return not only to our childhood, but to deal more healthily with our problems.

The following book was created thought so that you have a lot of time to devote your effort and above all the love to your art. Stop to contemplate every little detail, the stories hidden in each page. And if you are a kitten lover you will see one or another of the scenes in some drawings.

Without further ado, feel free to choose your colors, tones and your adventurous spirit to paint the following pages, enjoy it!

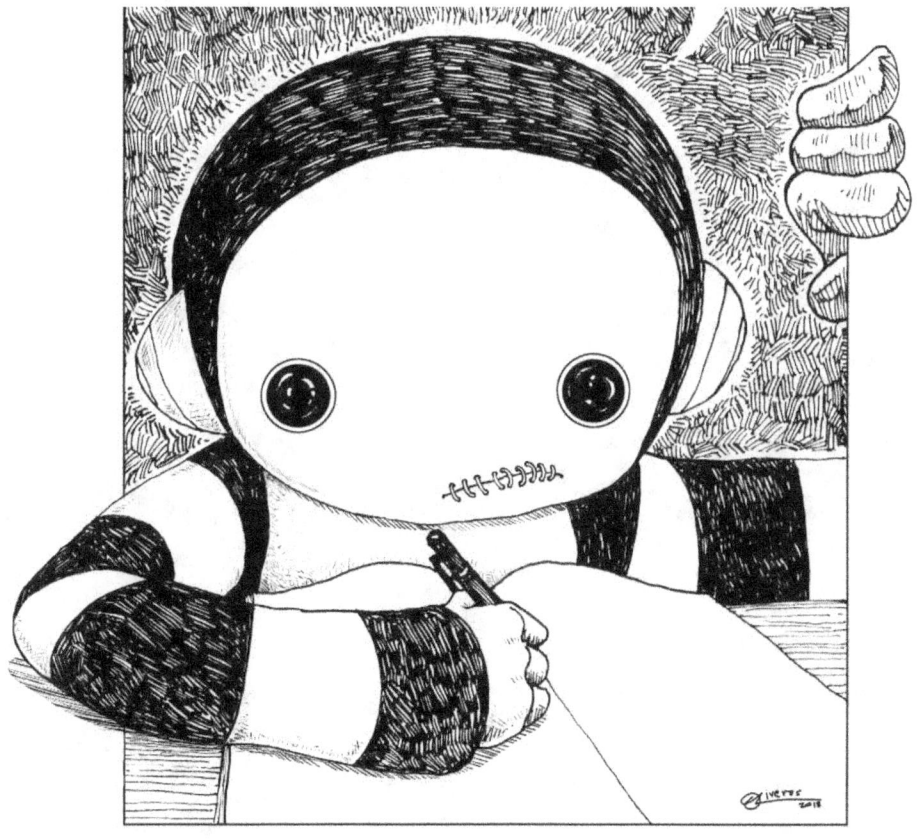

INYOURHEAD.

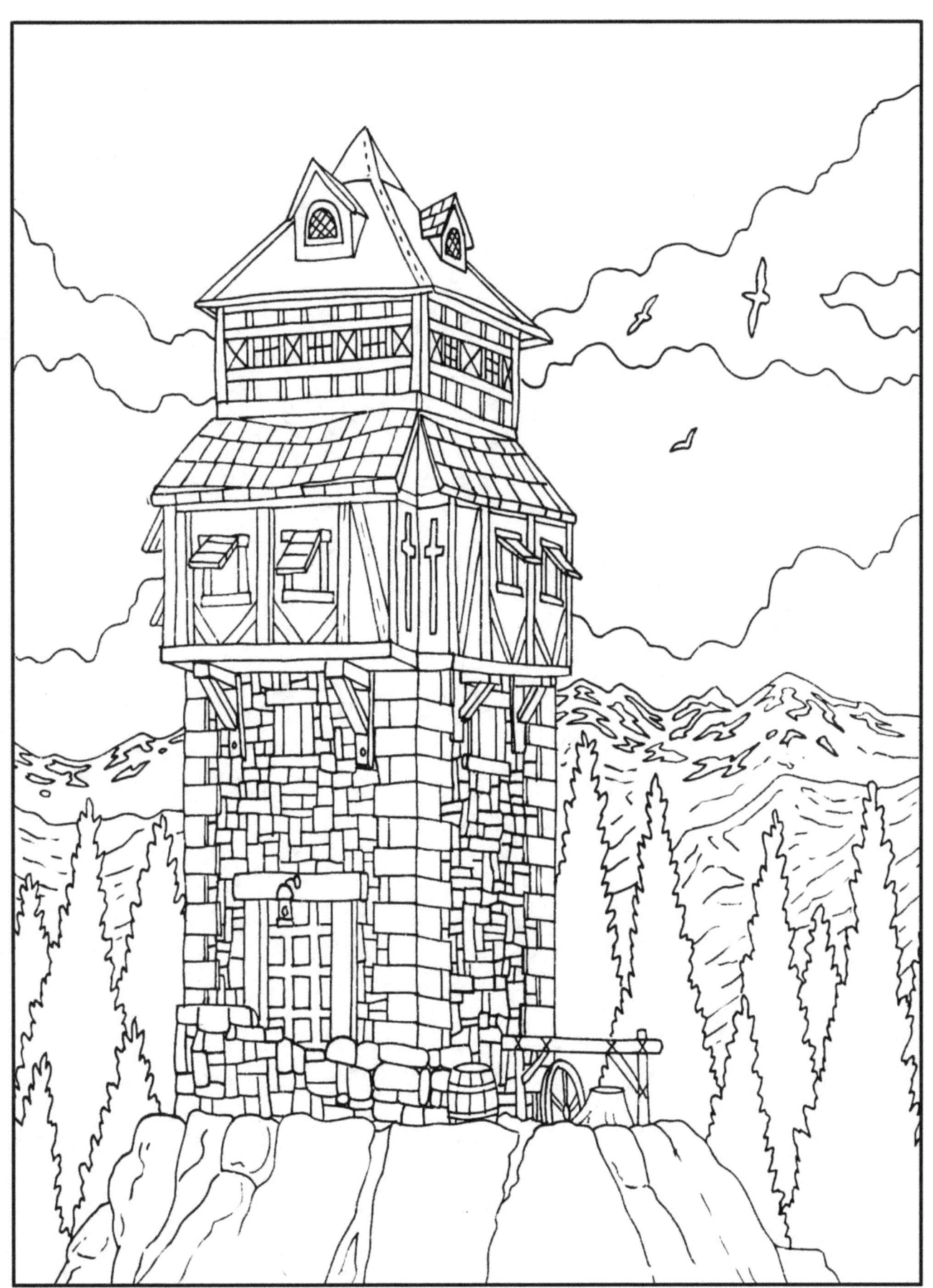

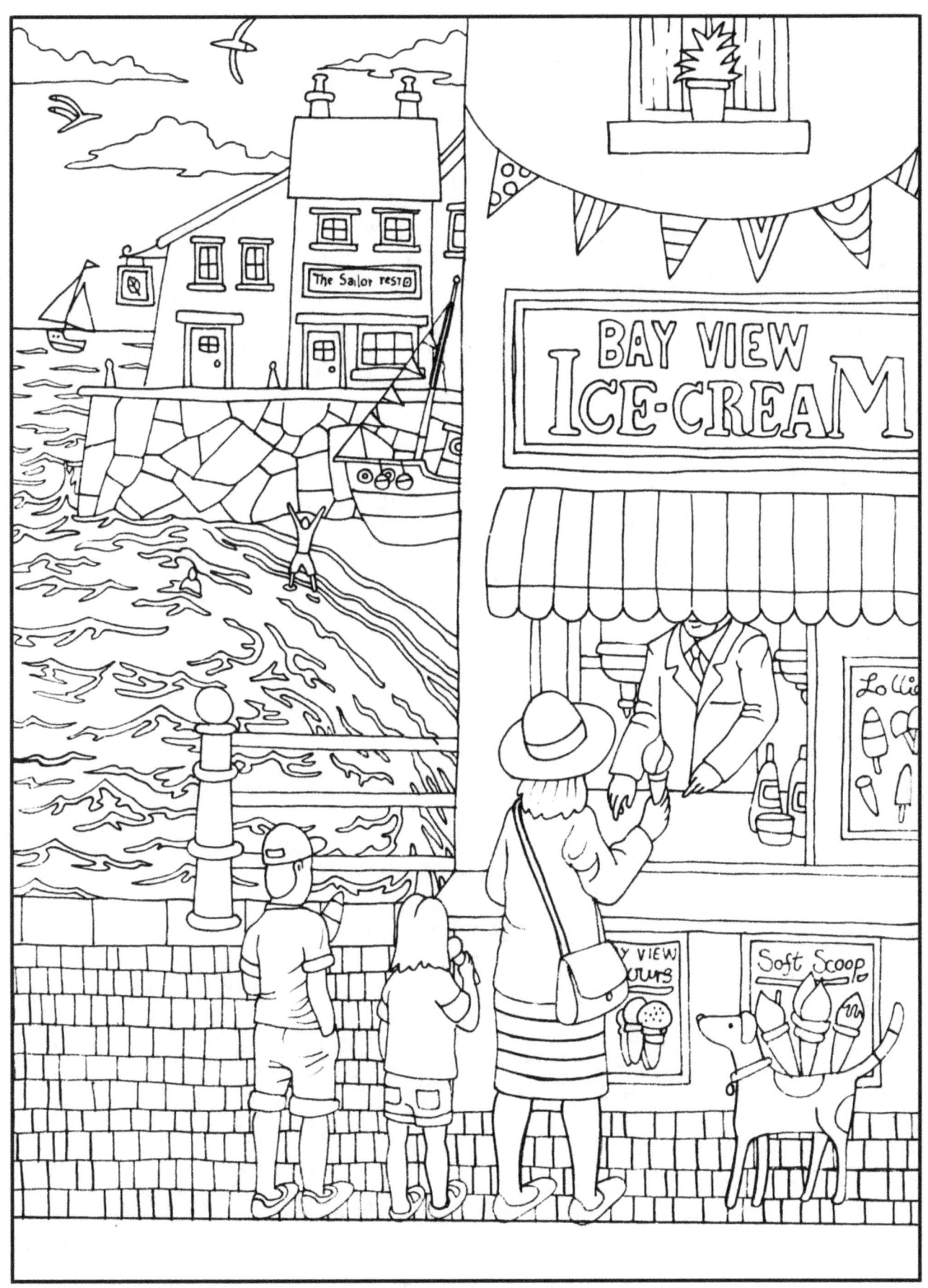

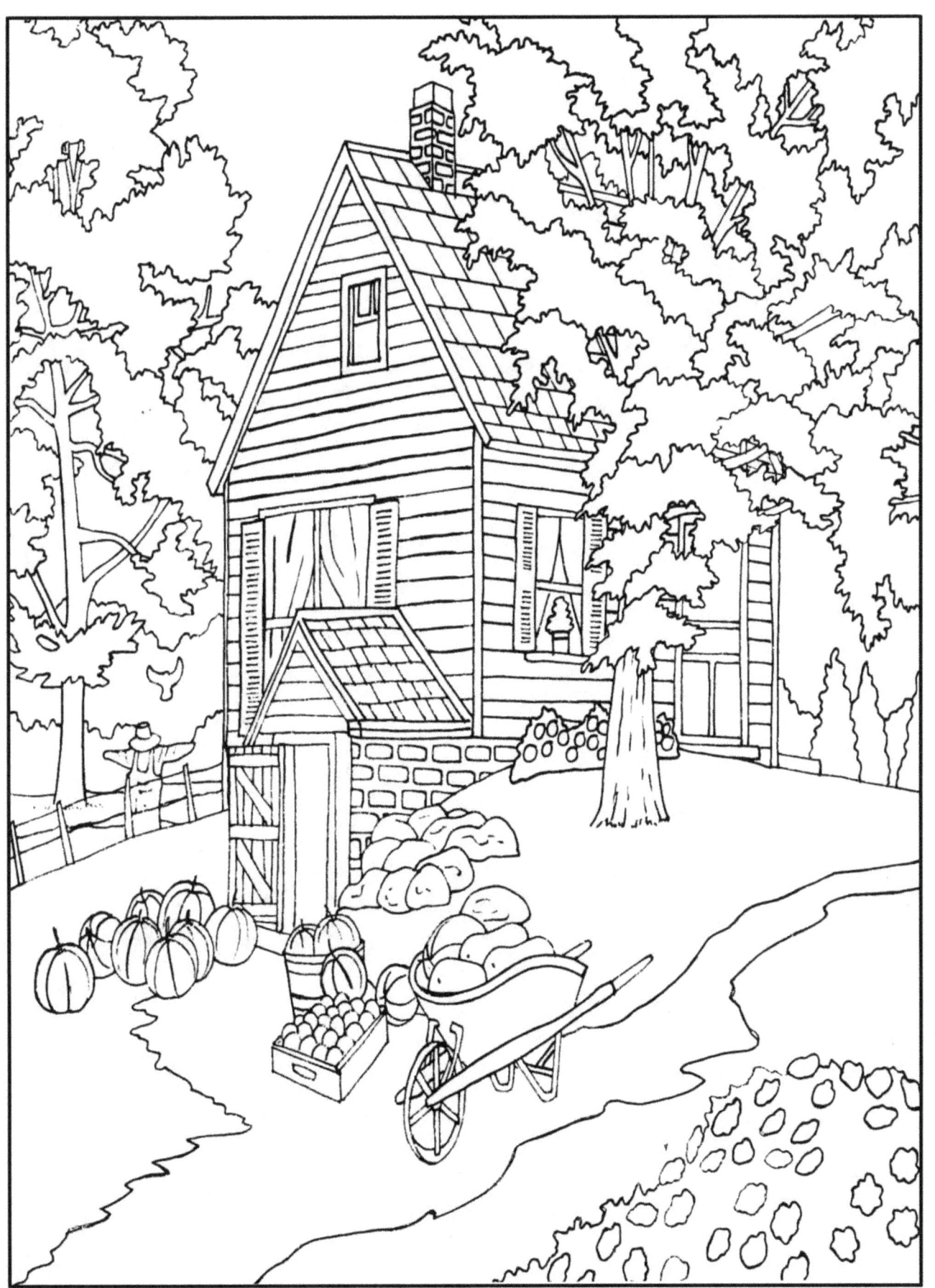

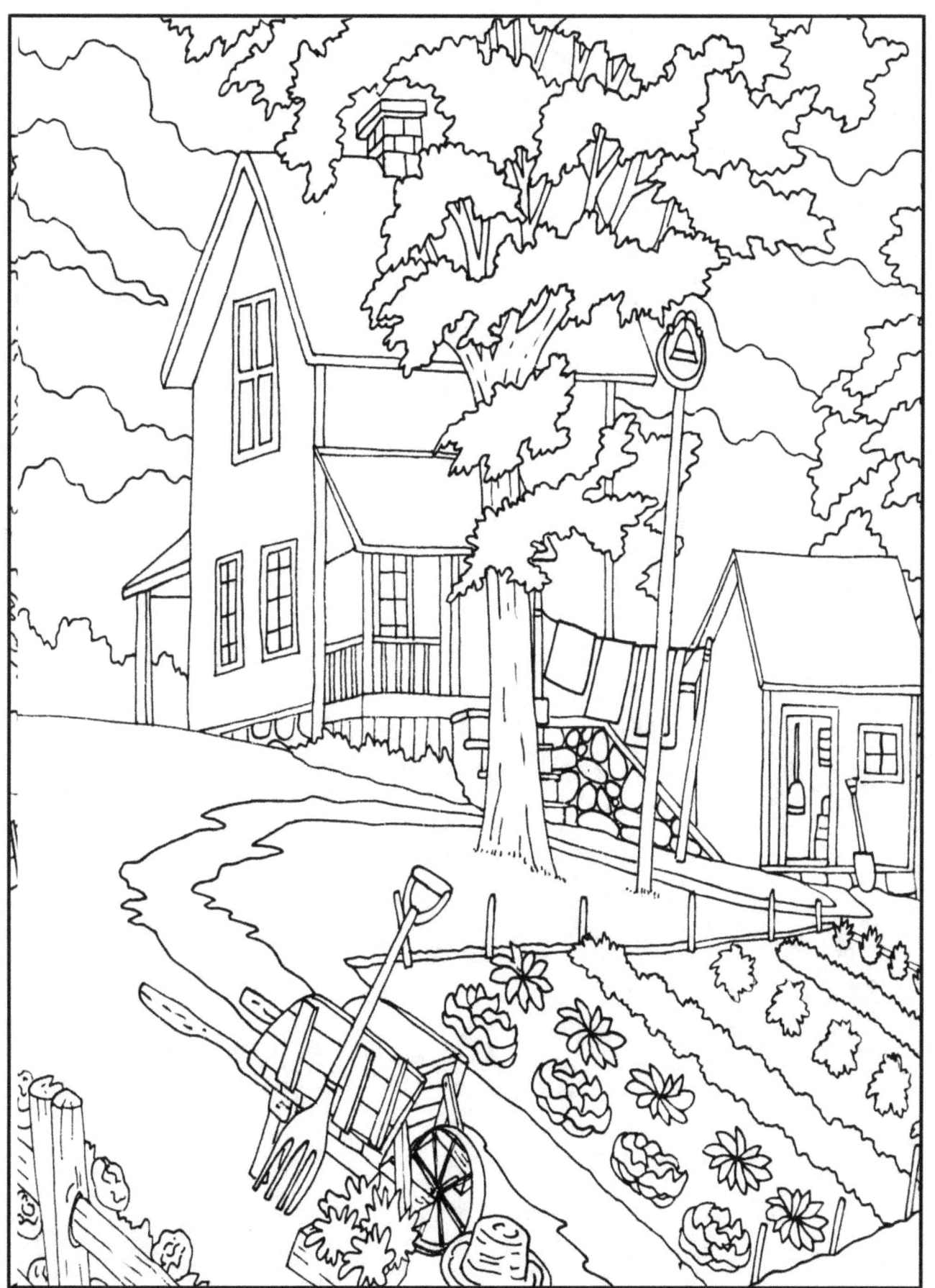

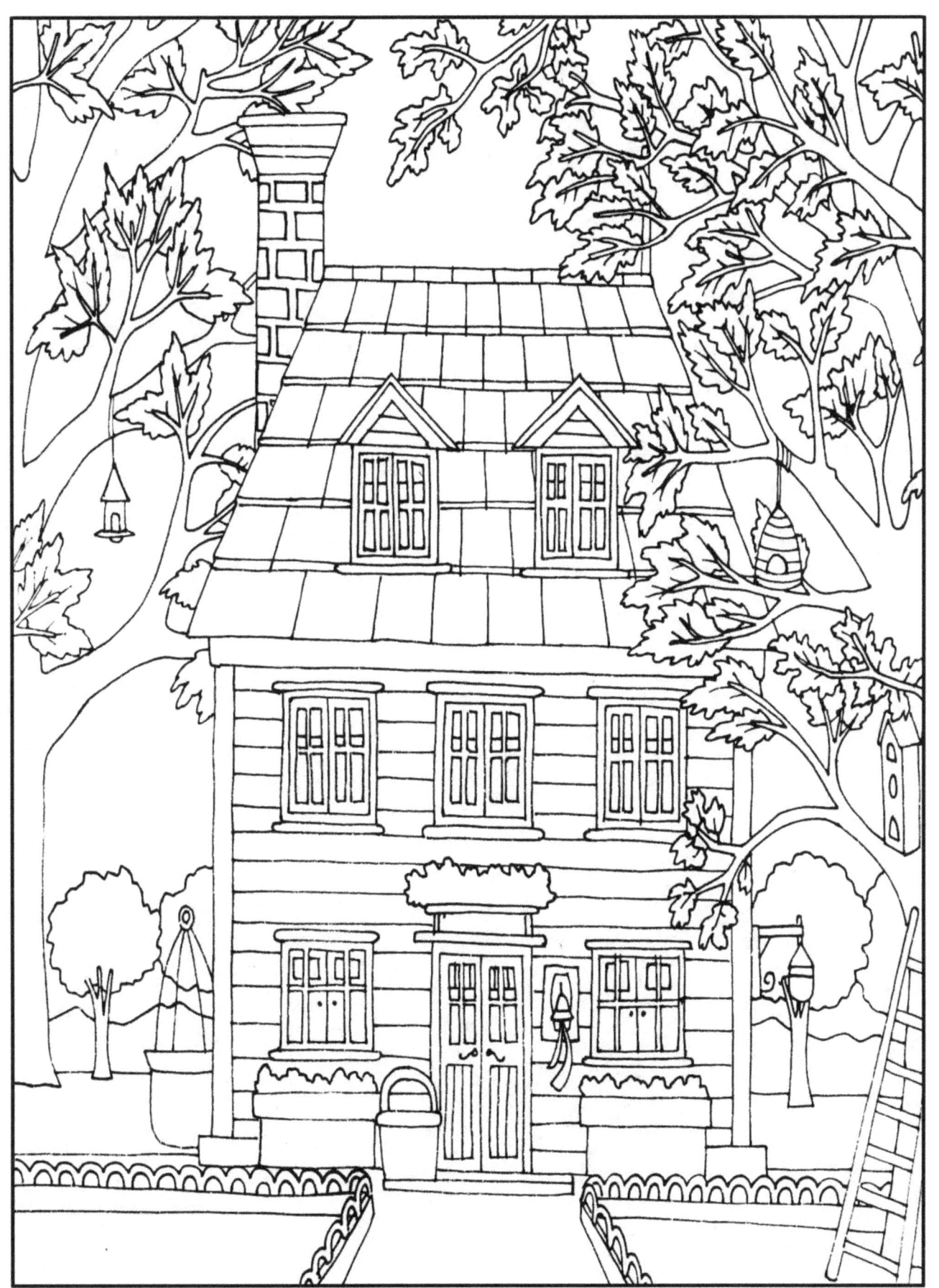

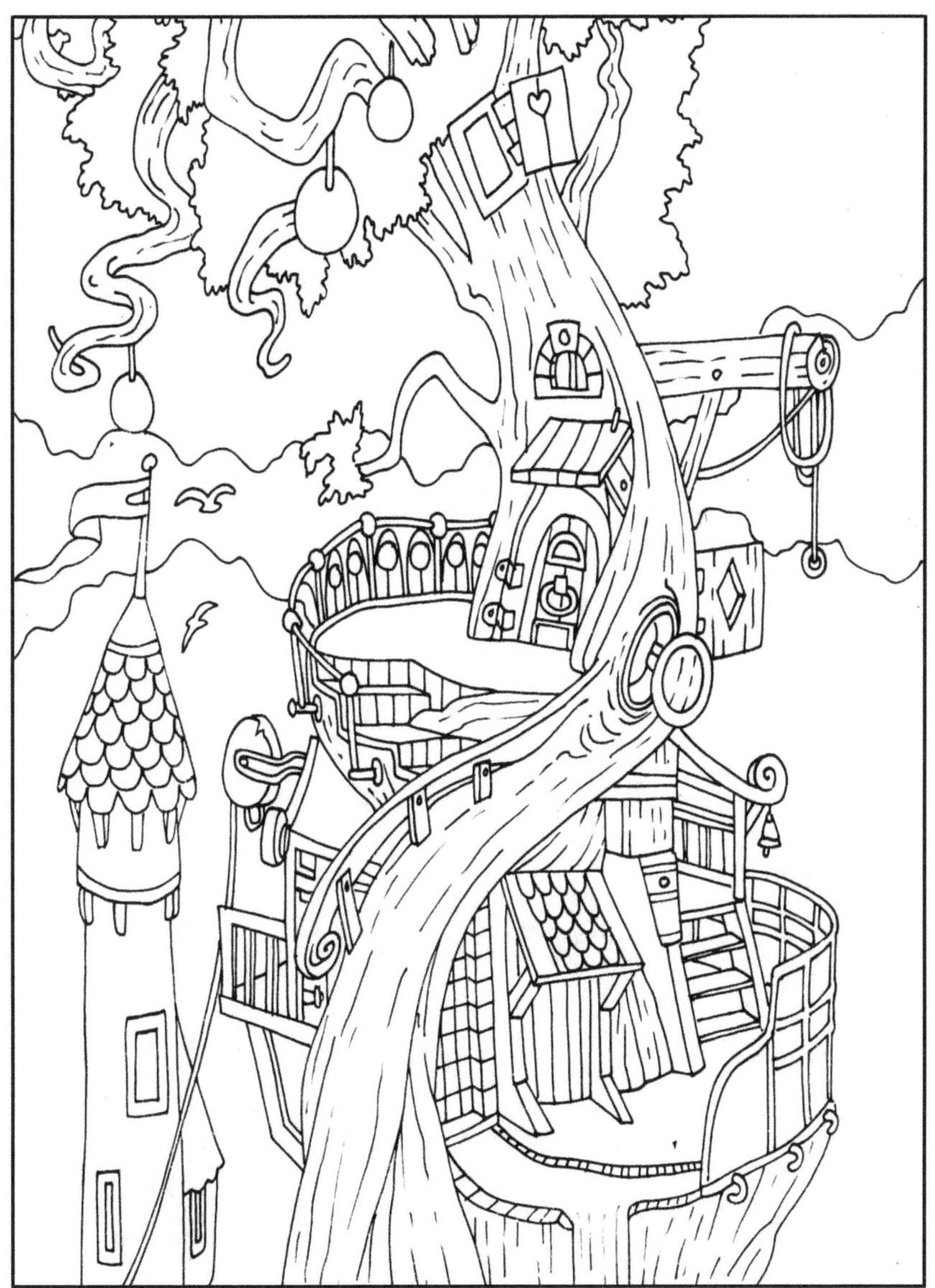

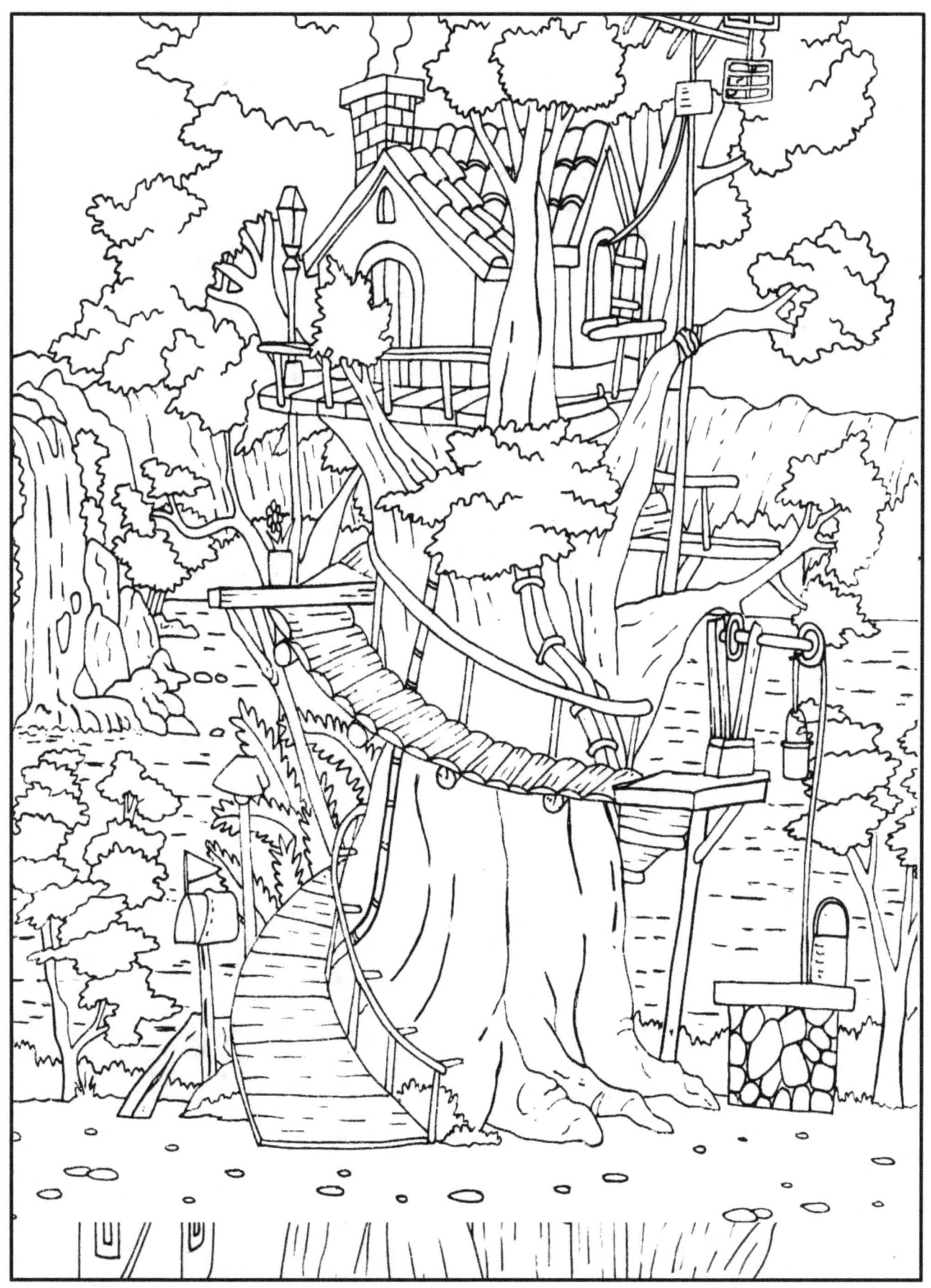

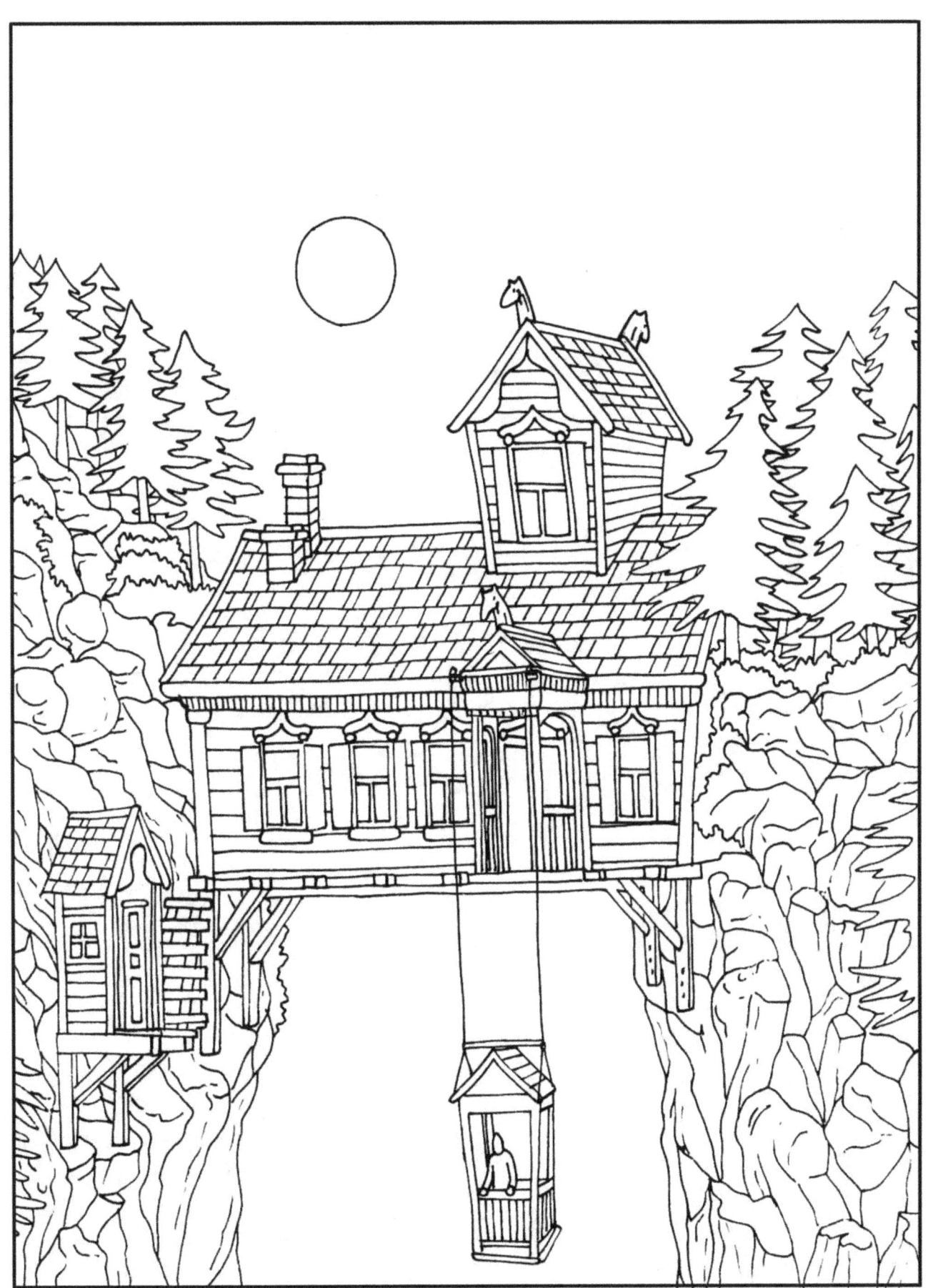

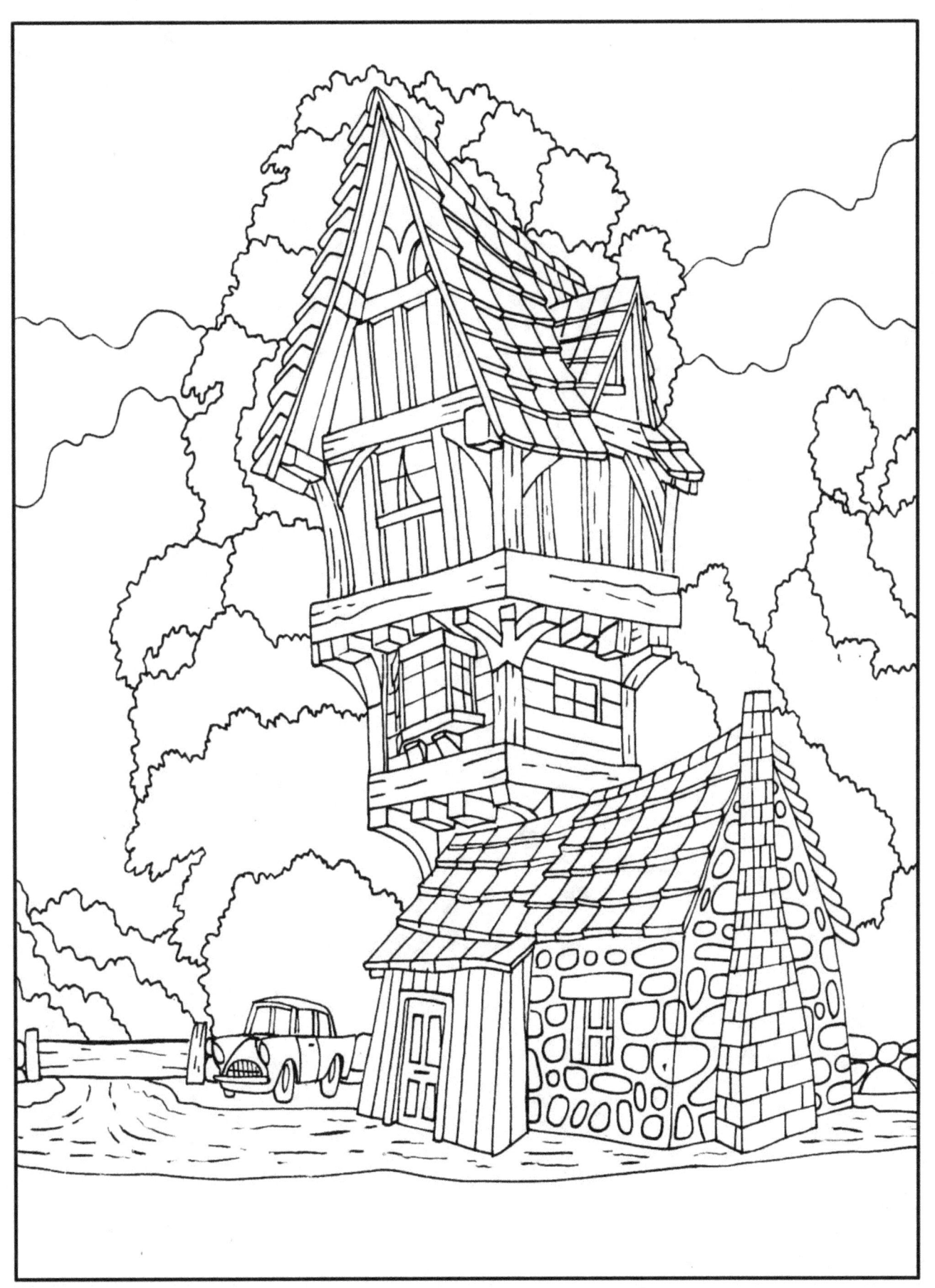

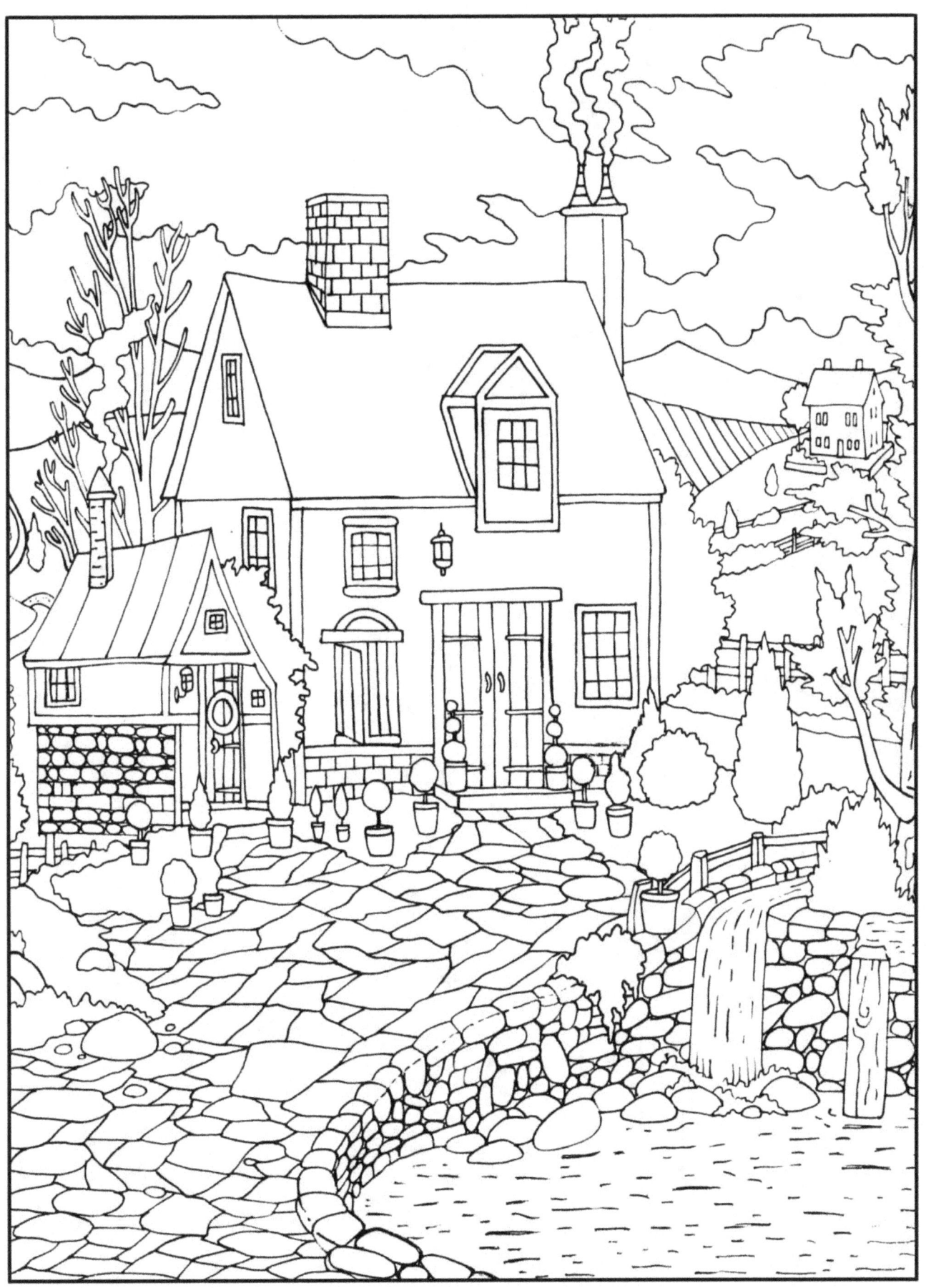

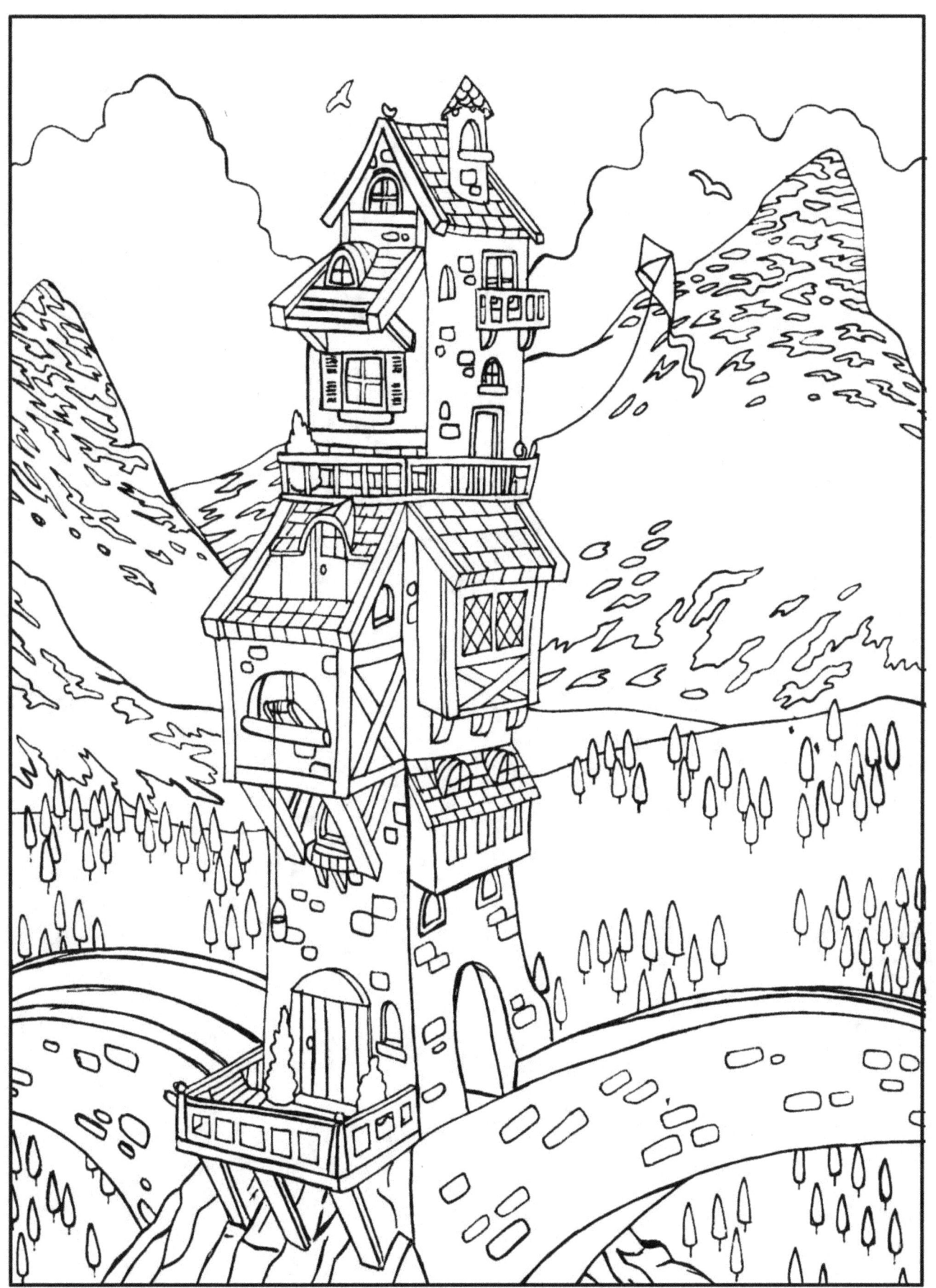

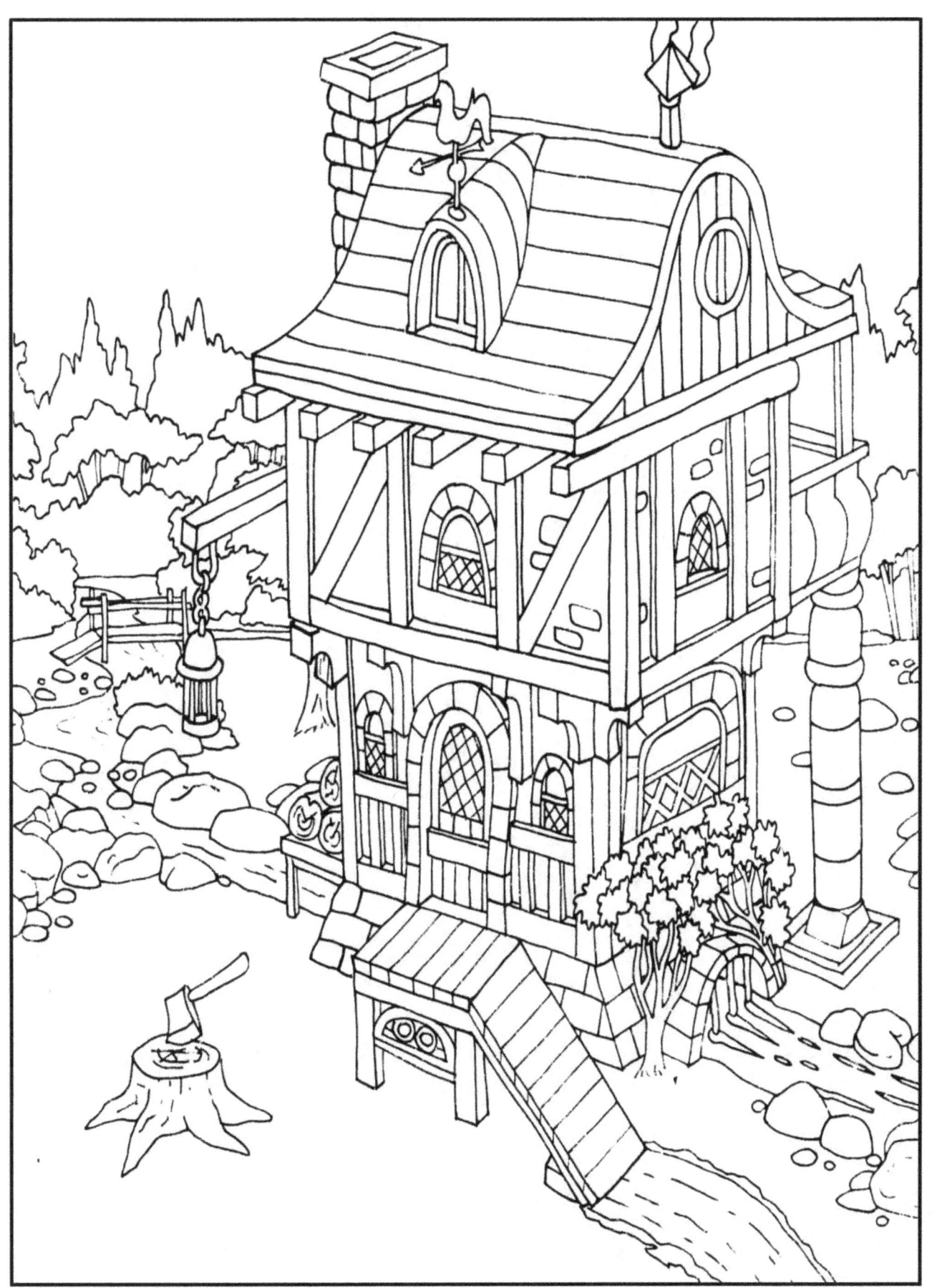

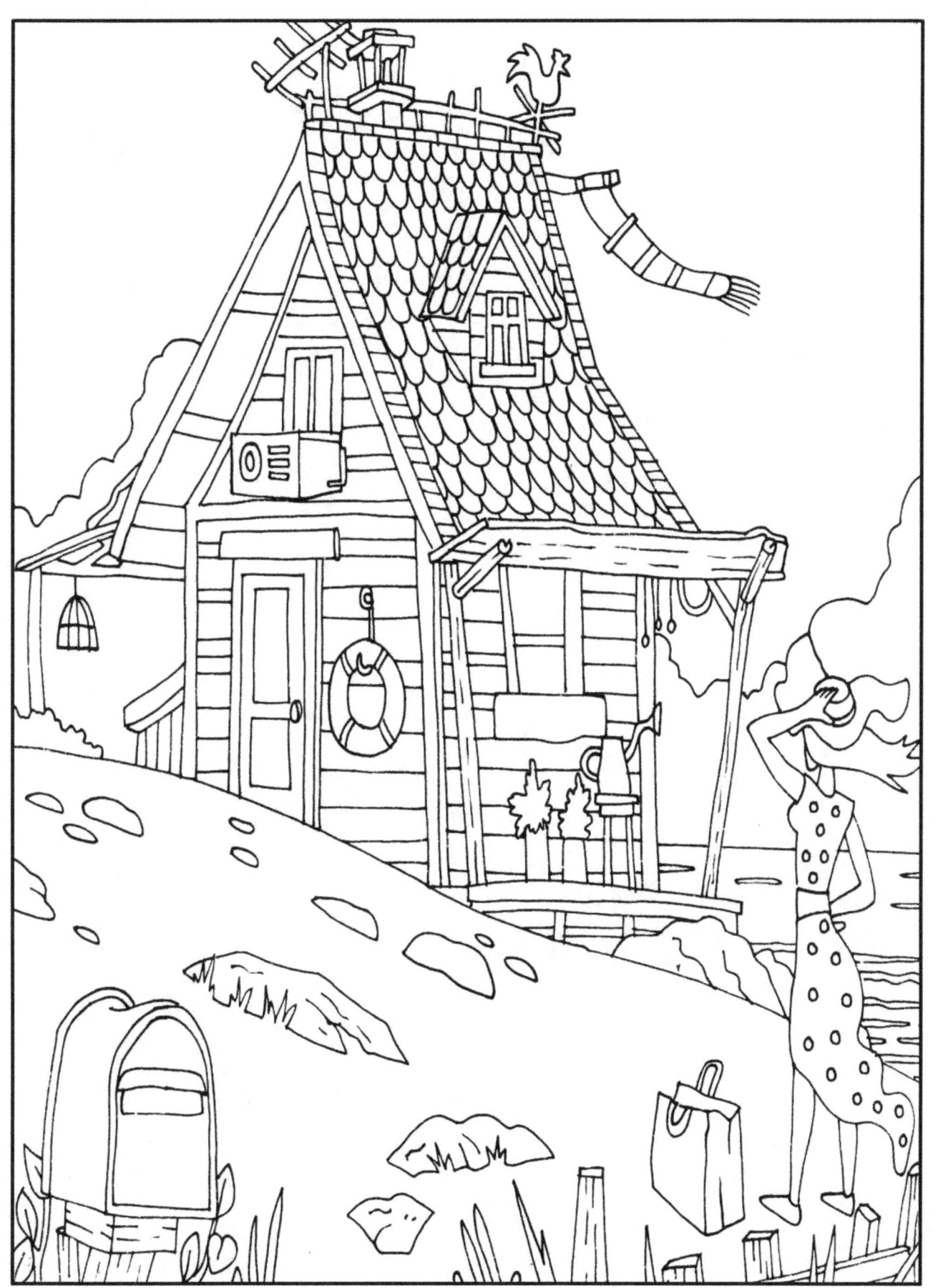

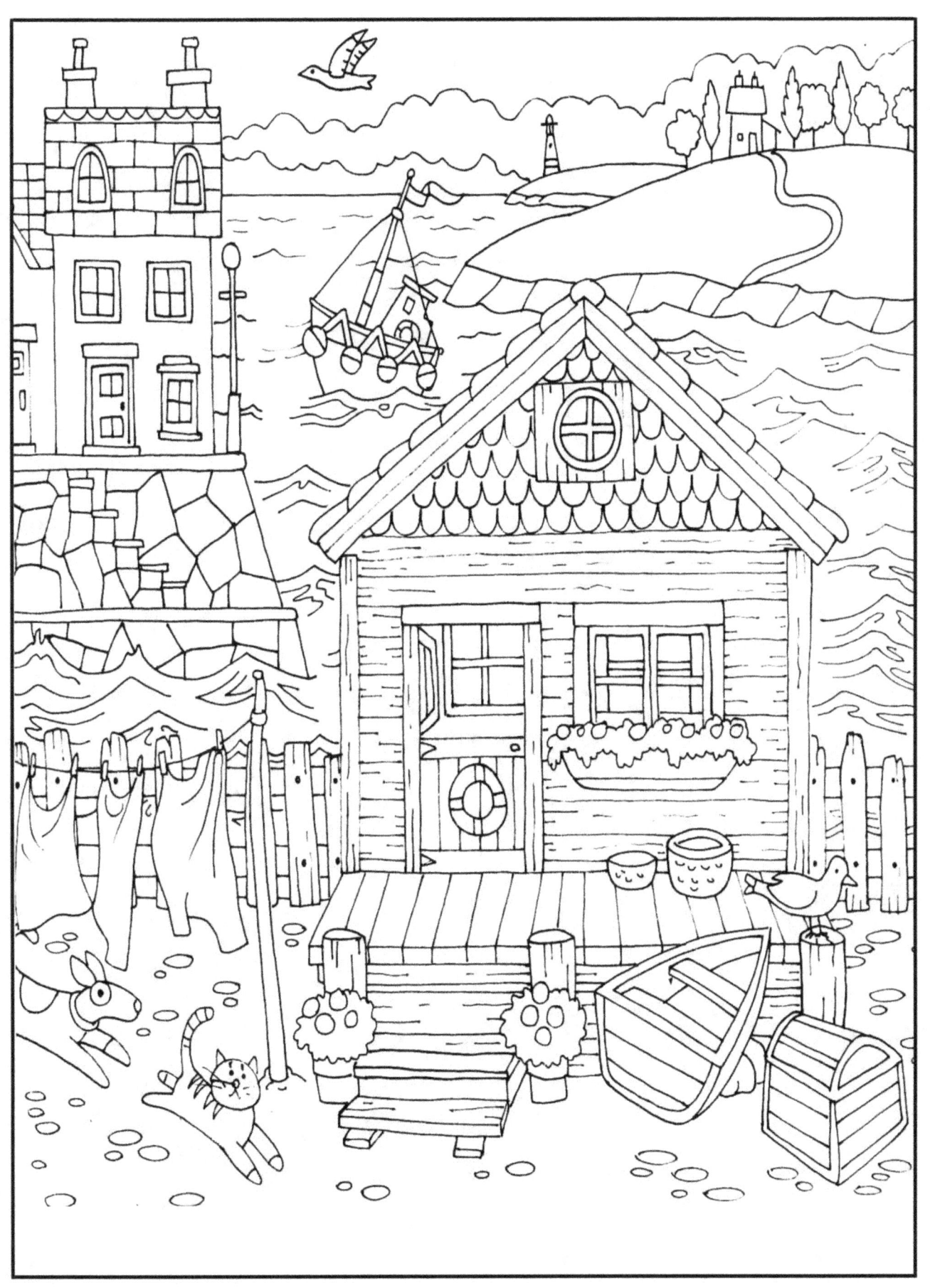

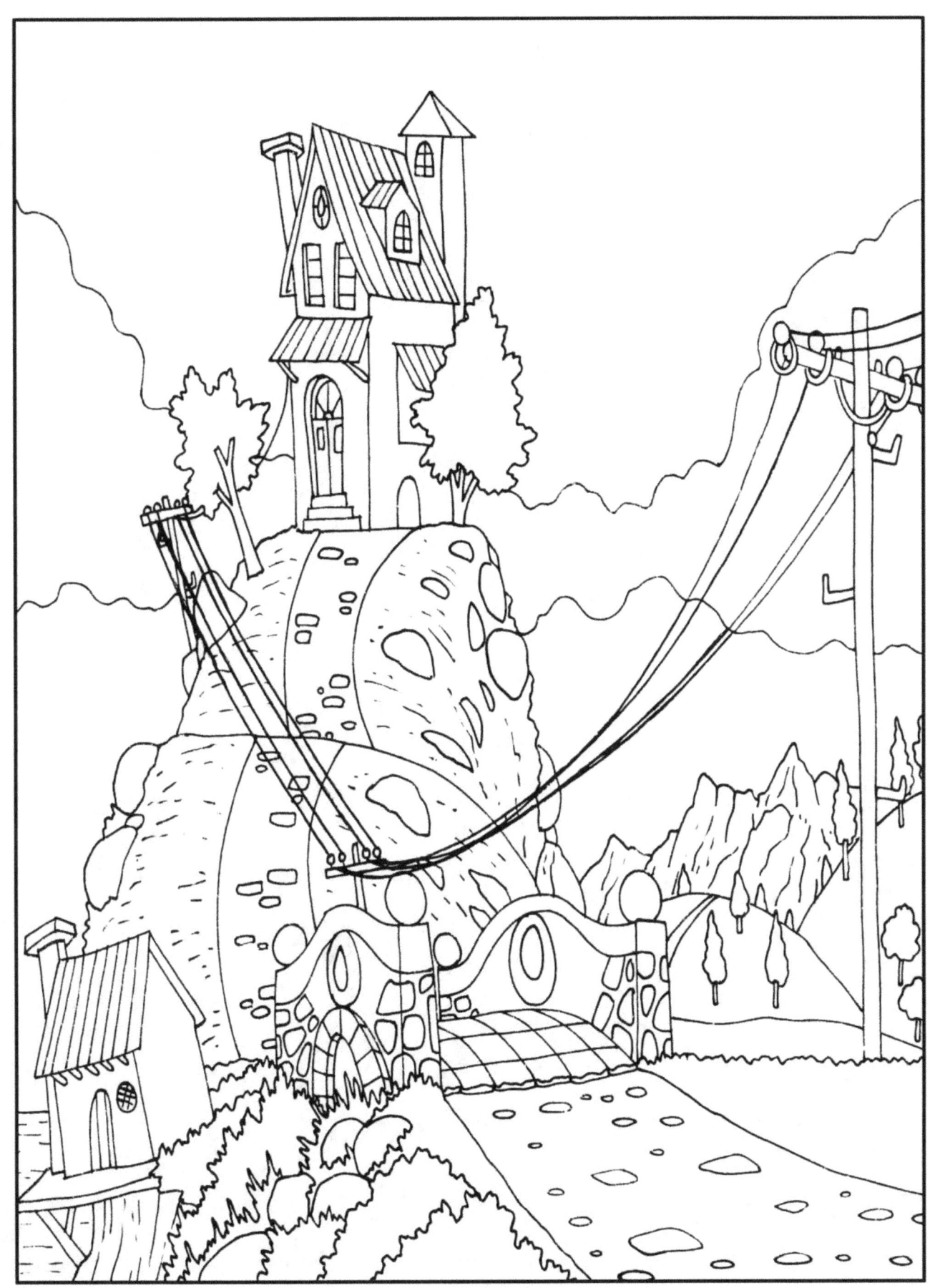

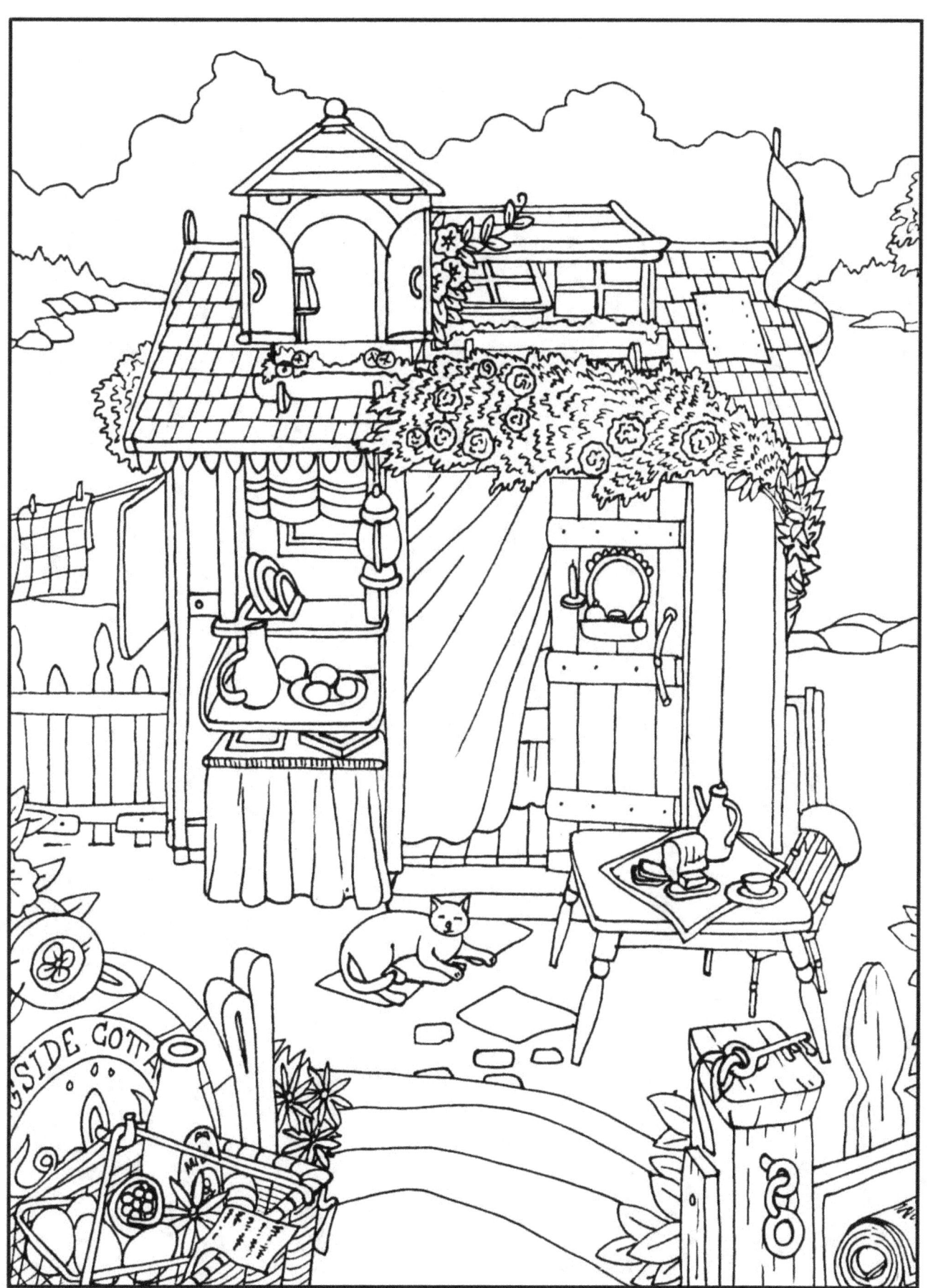

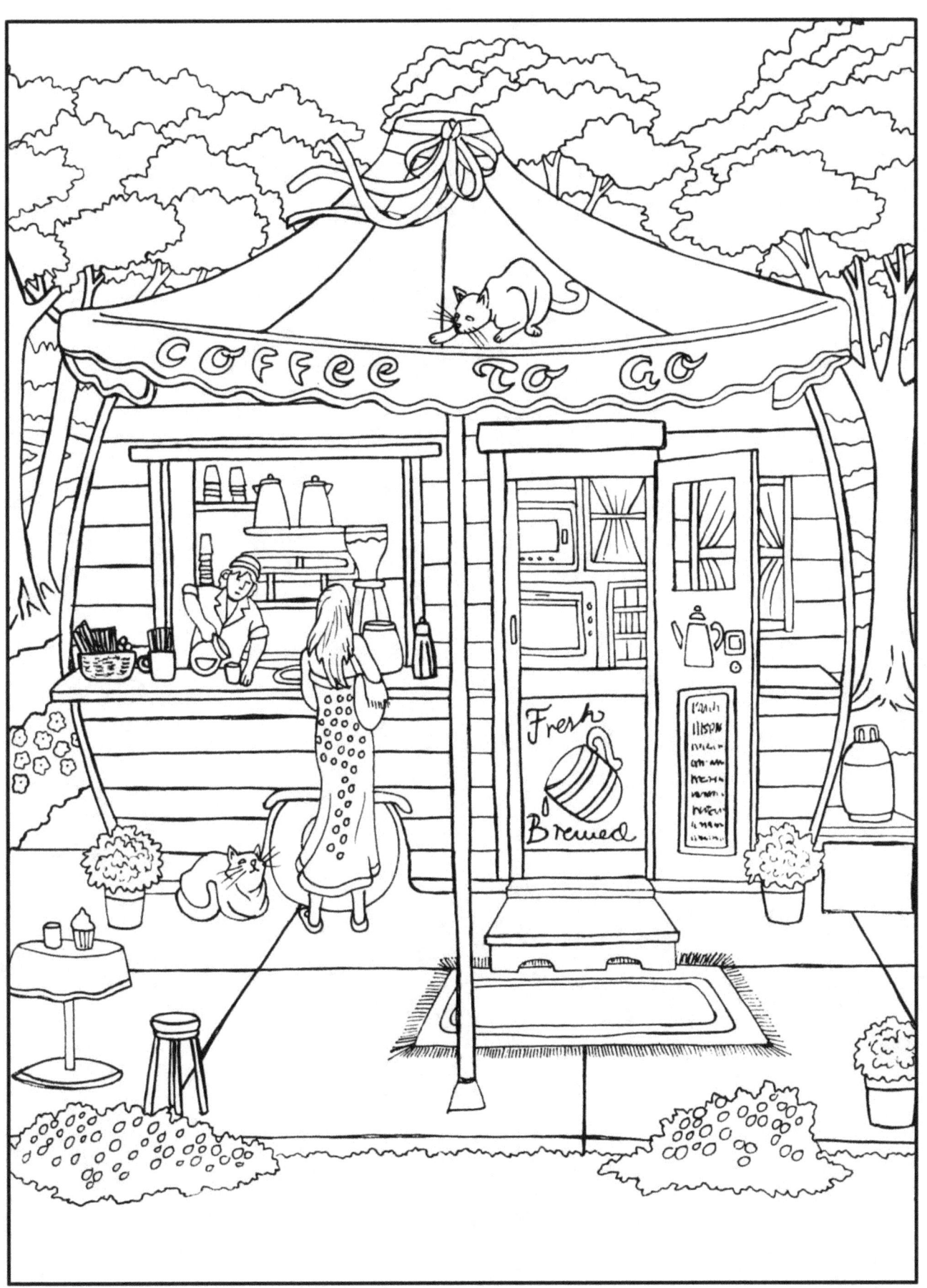

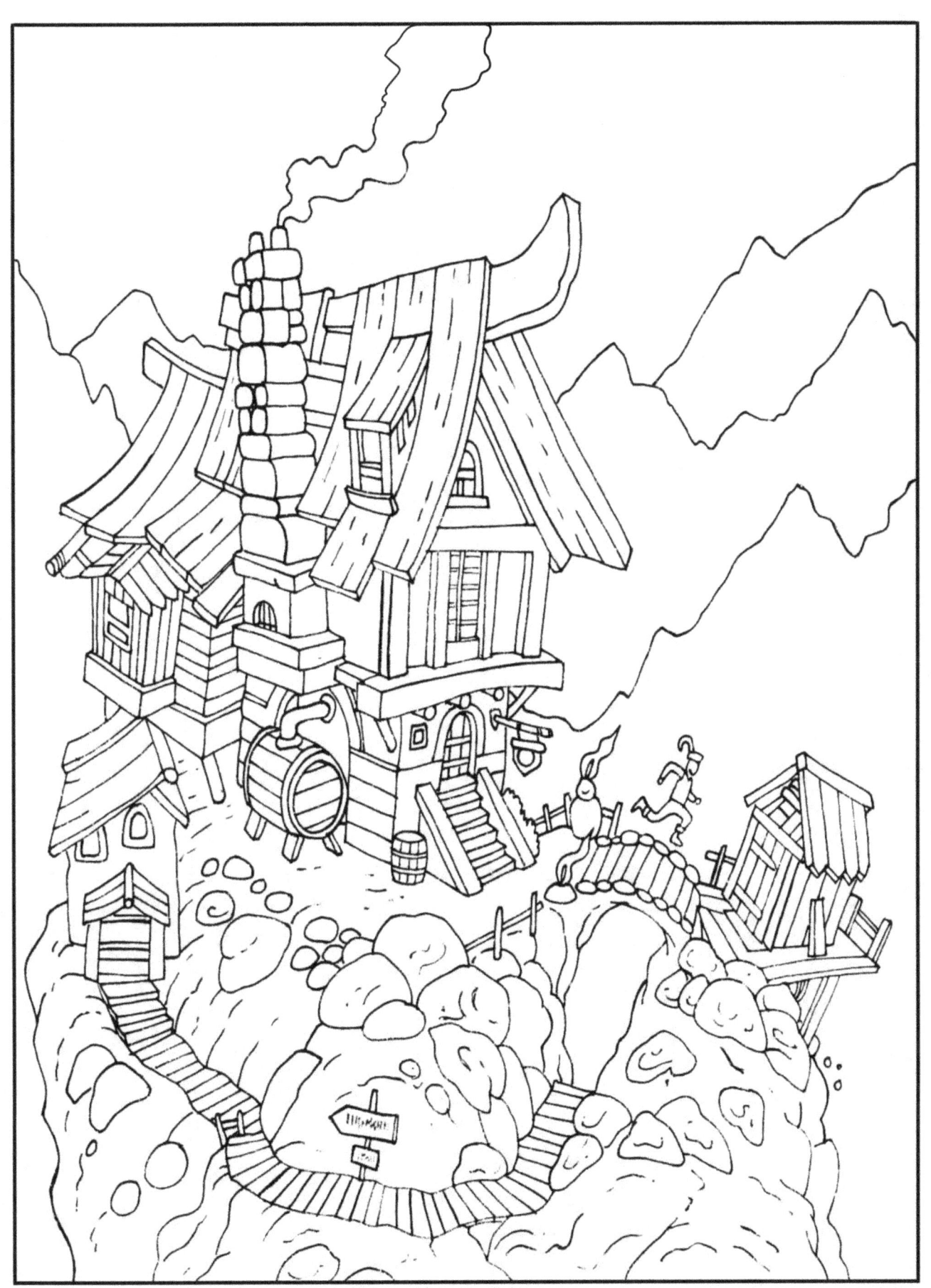

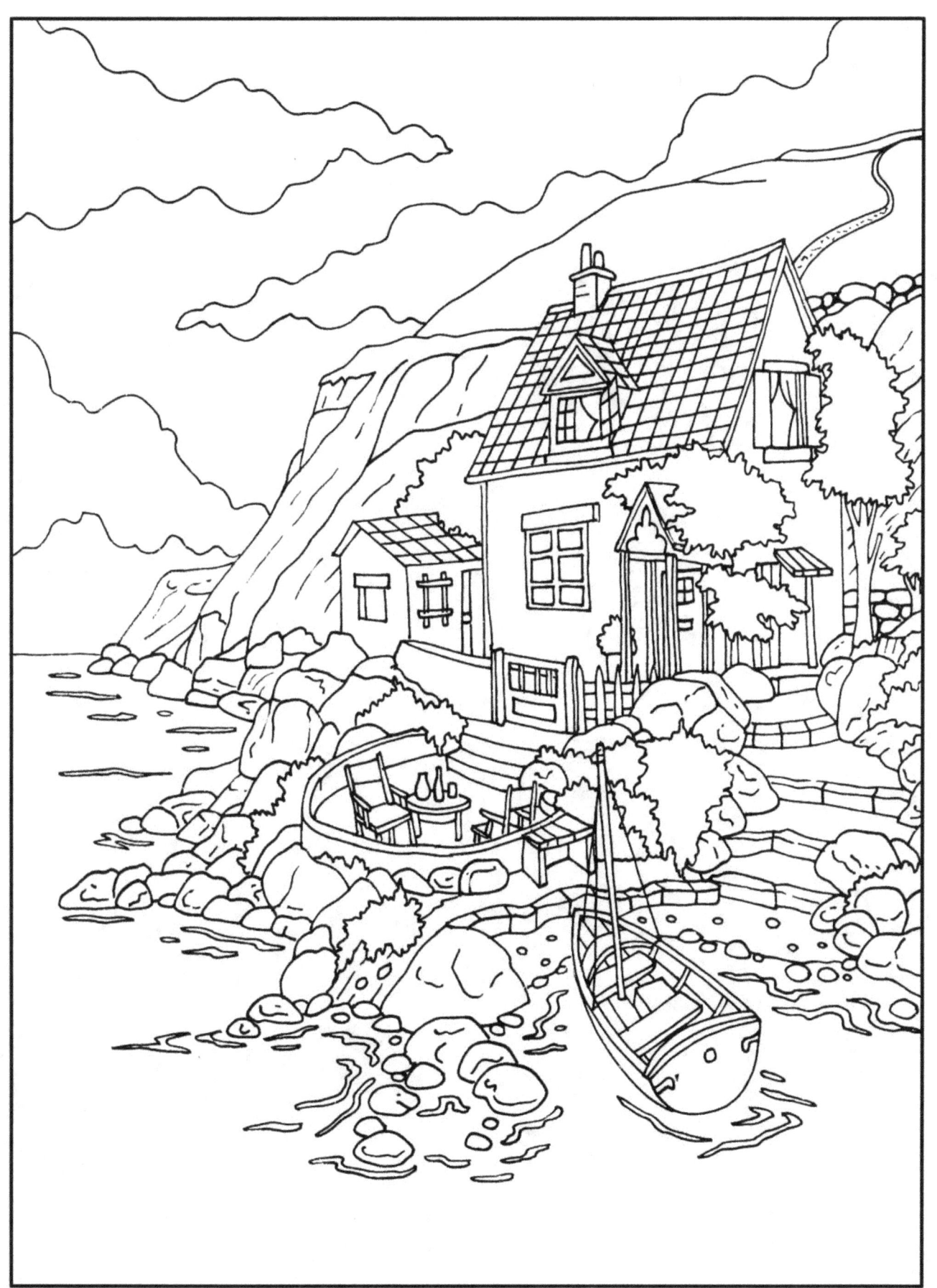

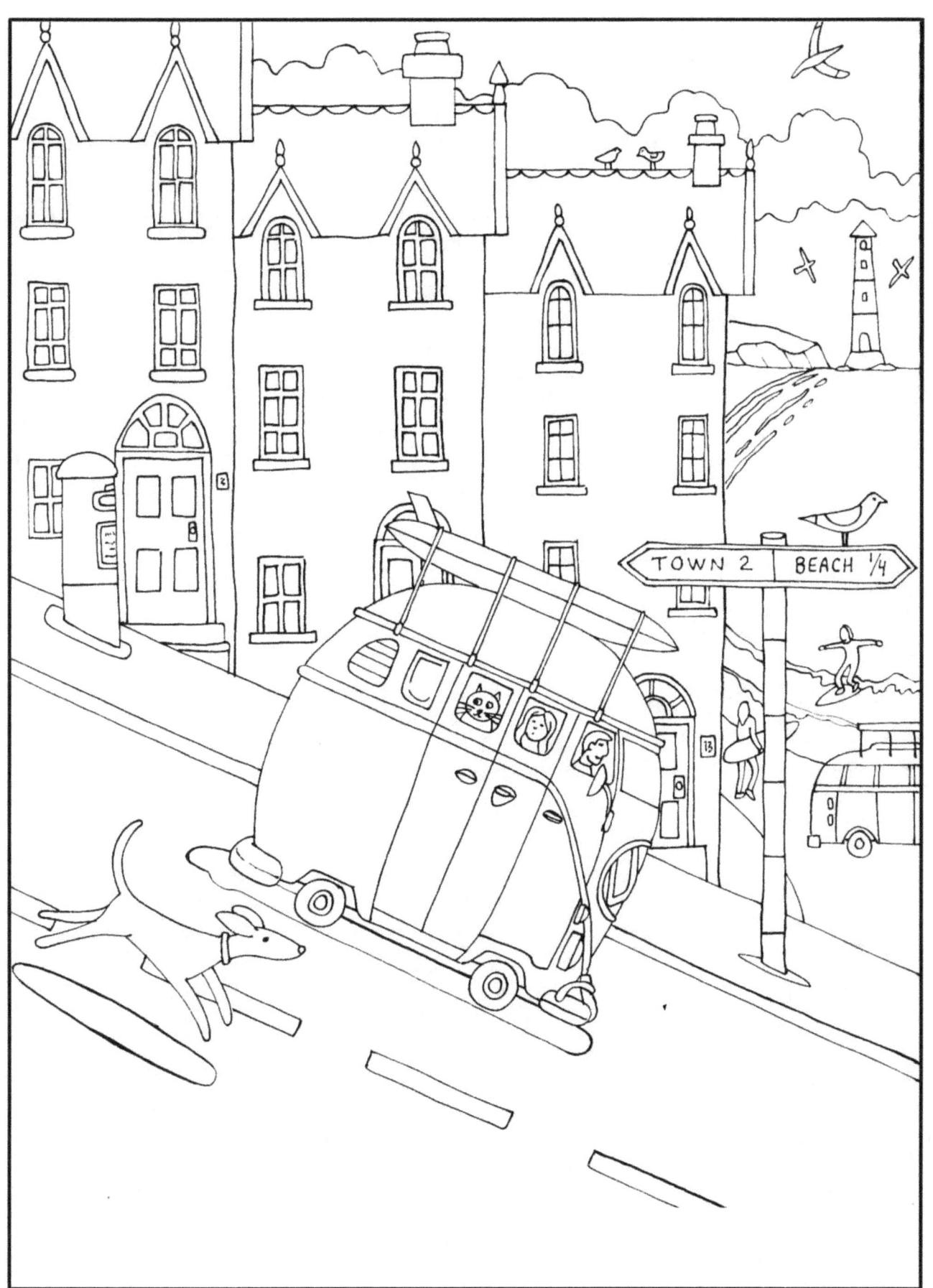

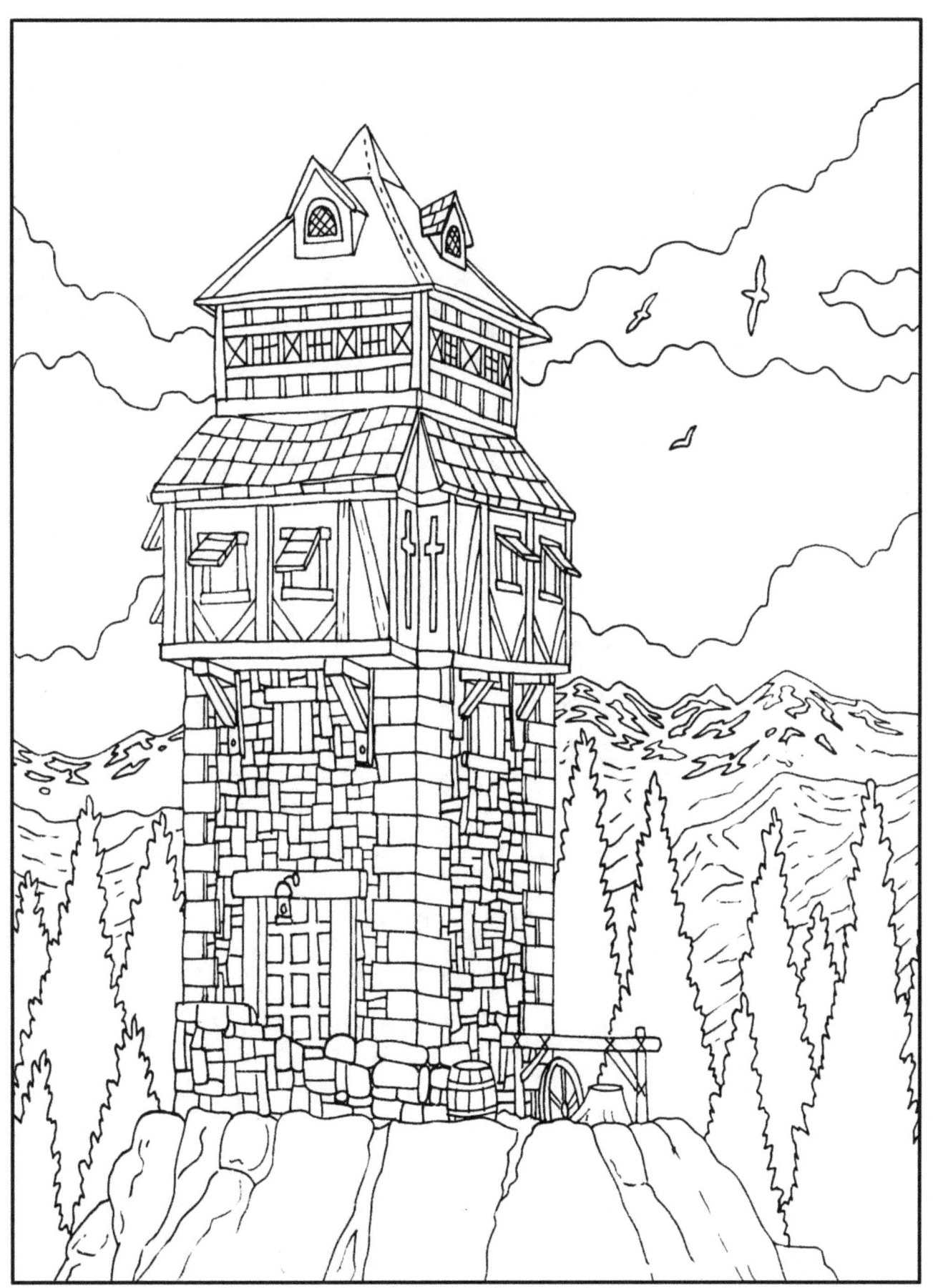

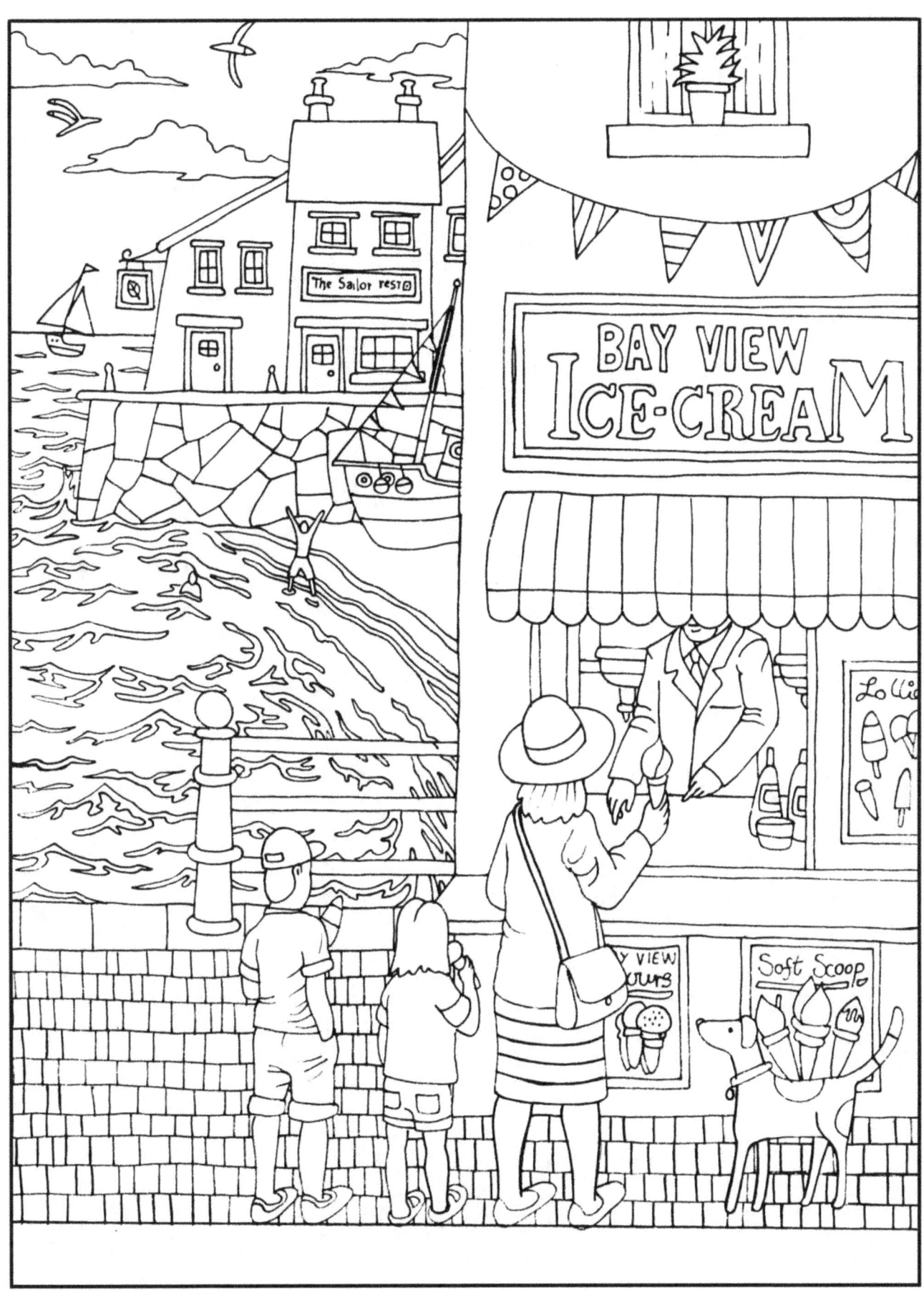

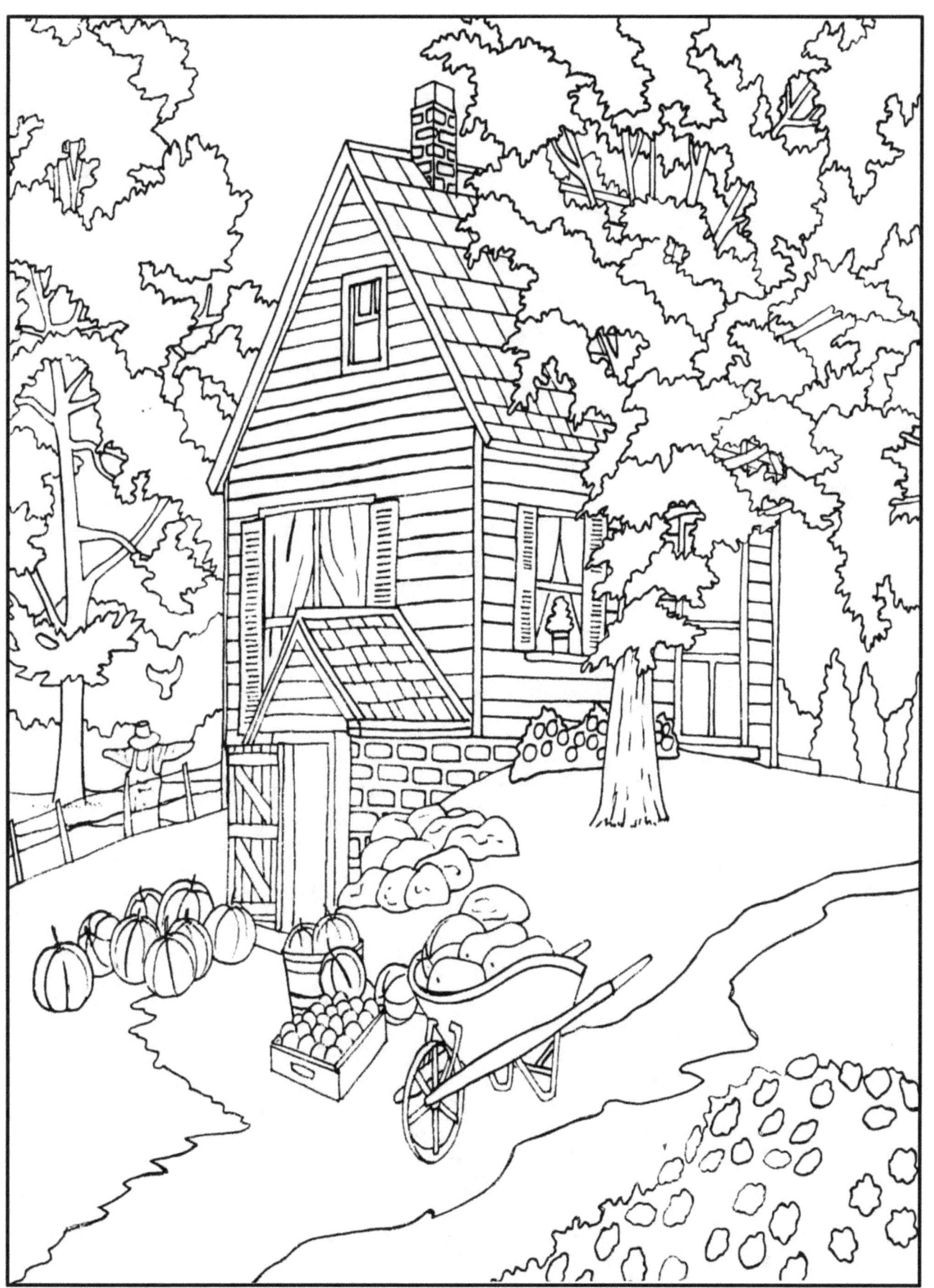

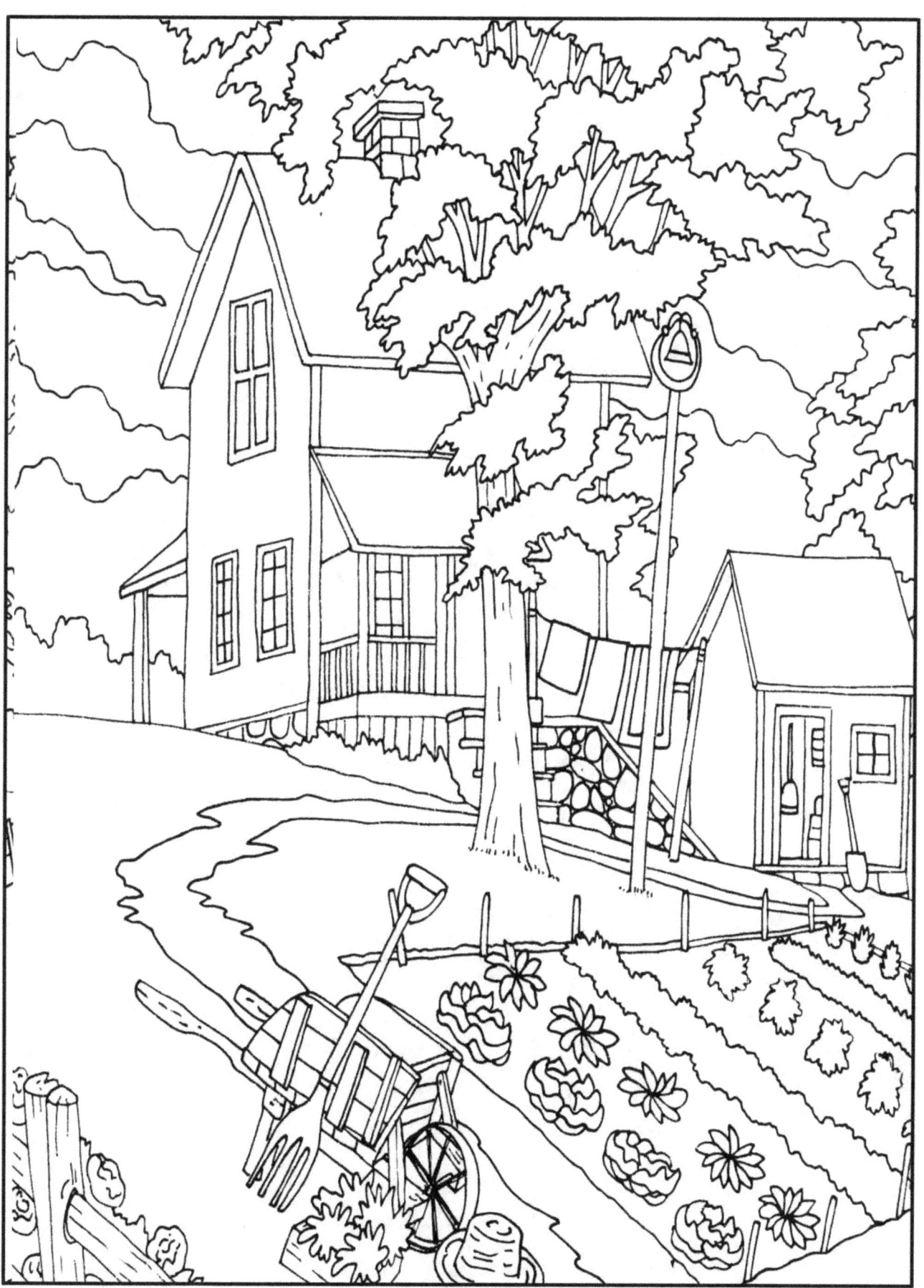

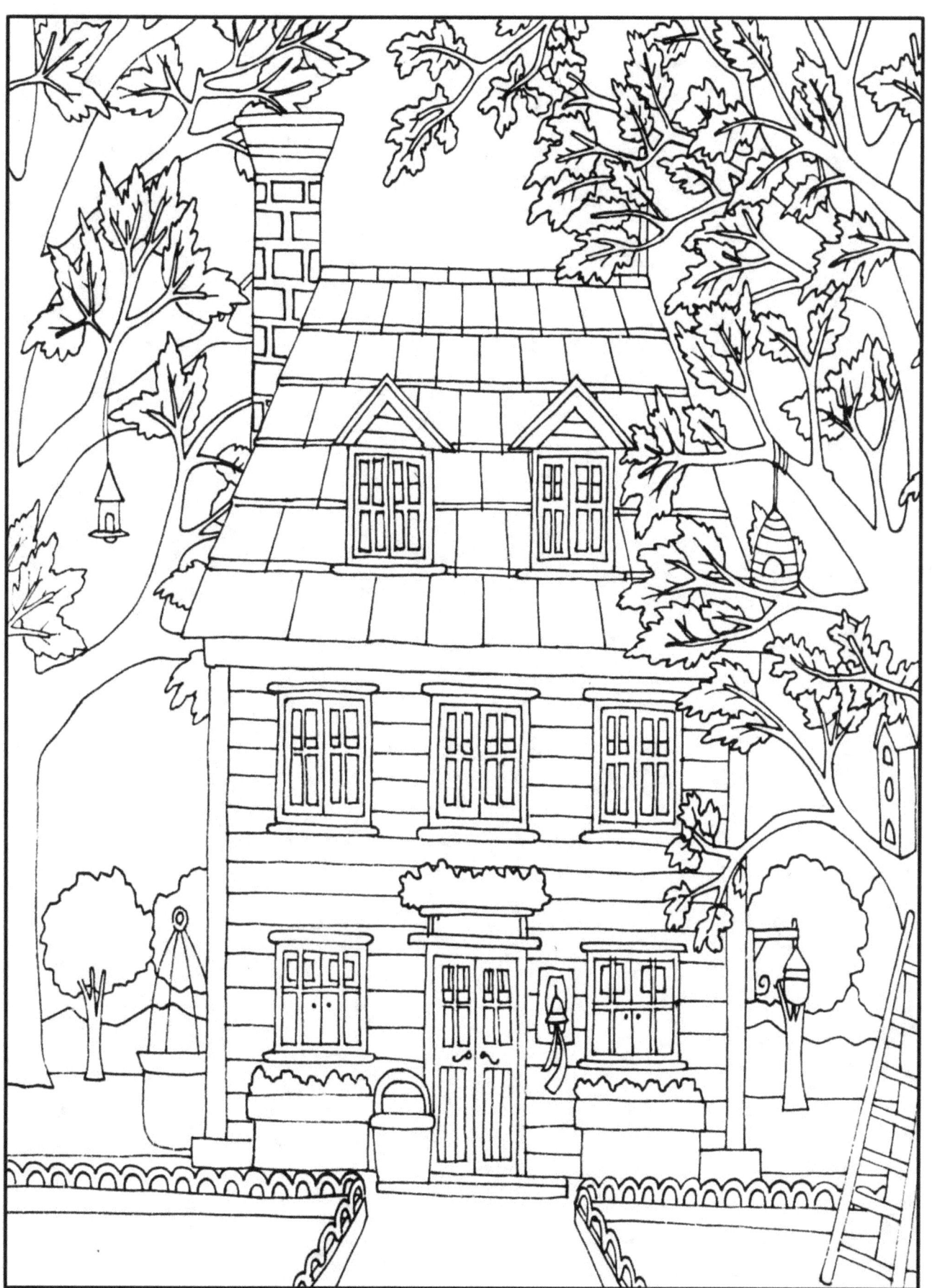

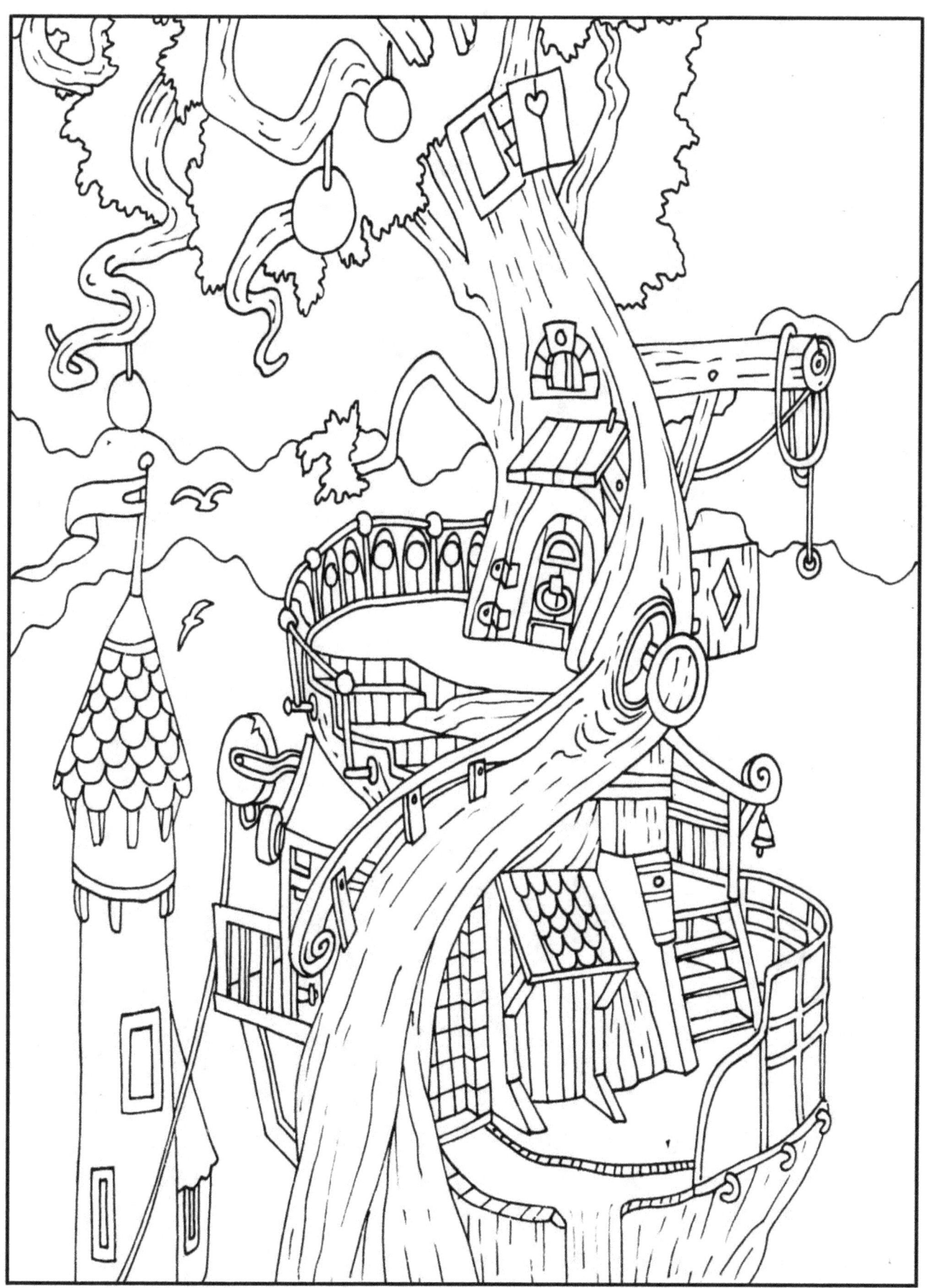

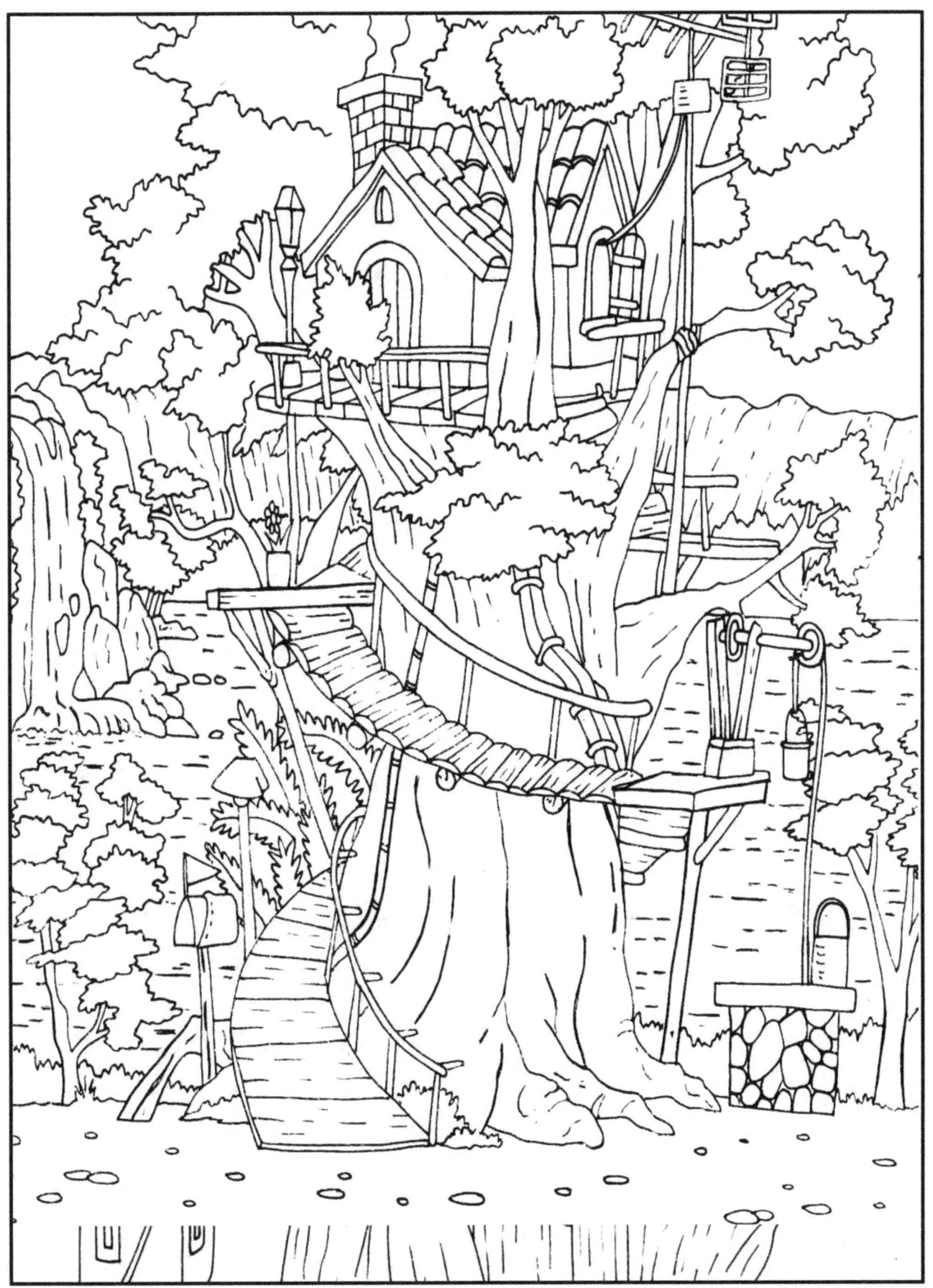

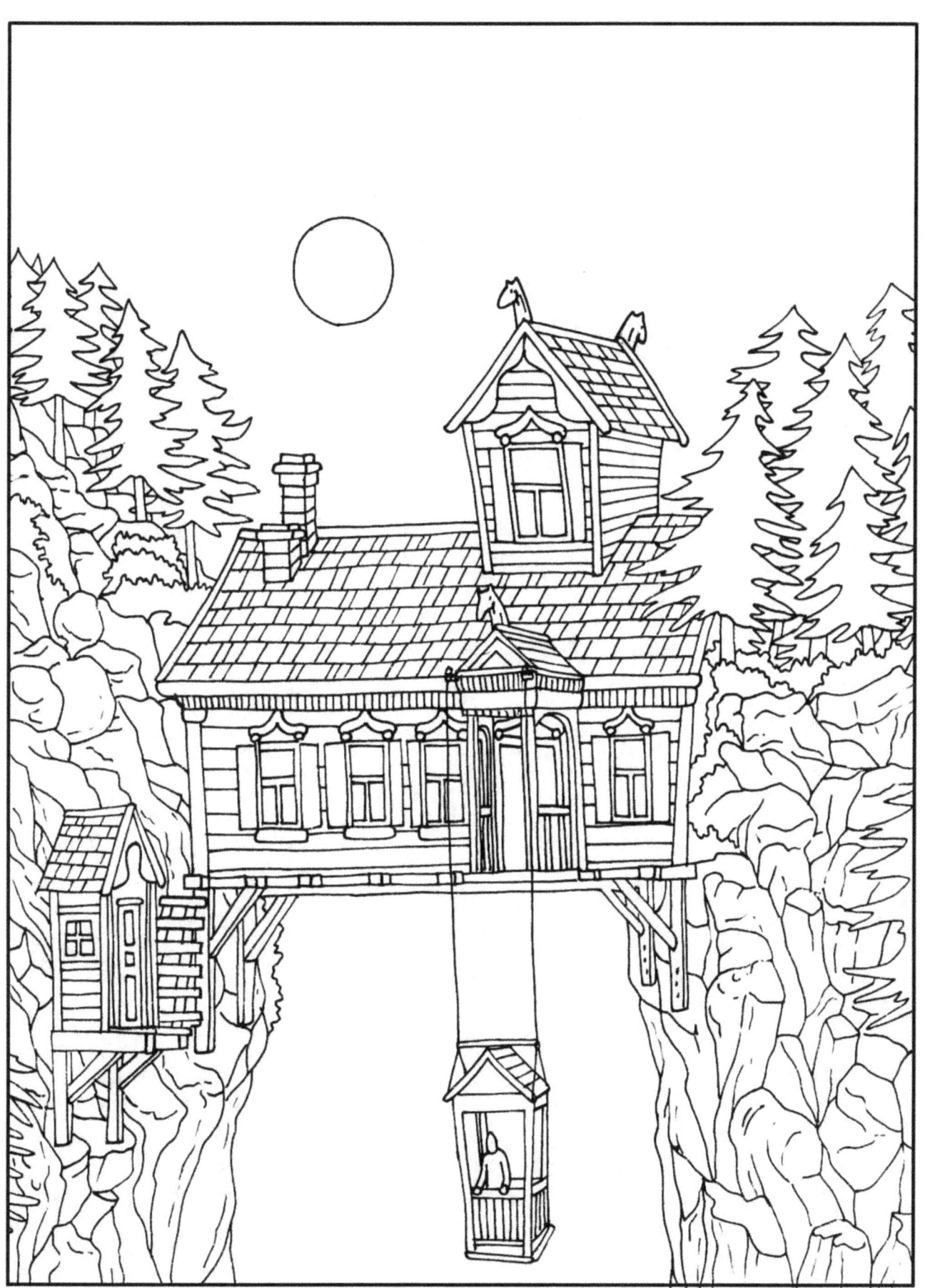

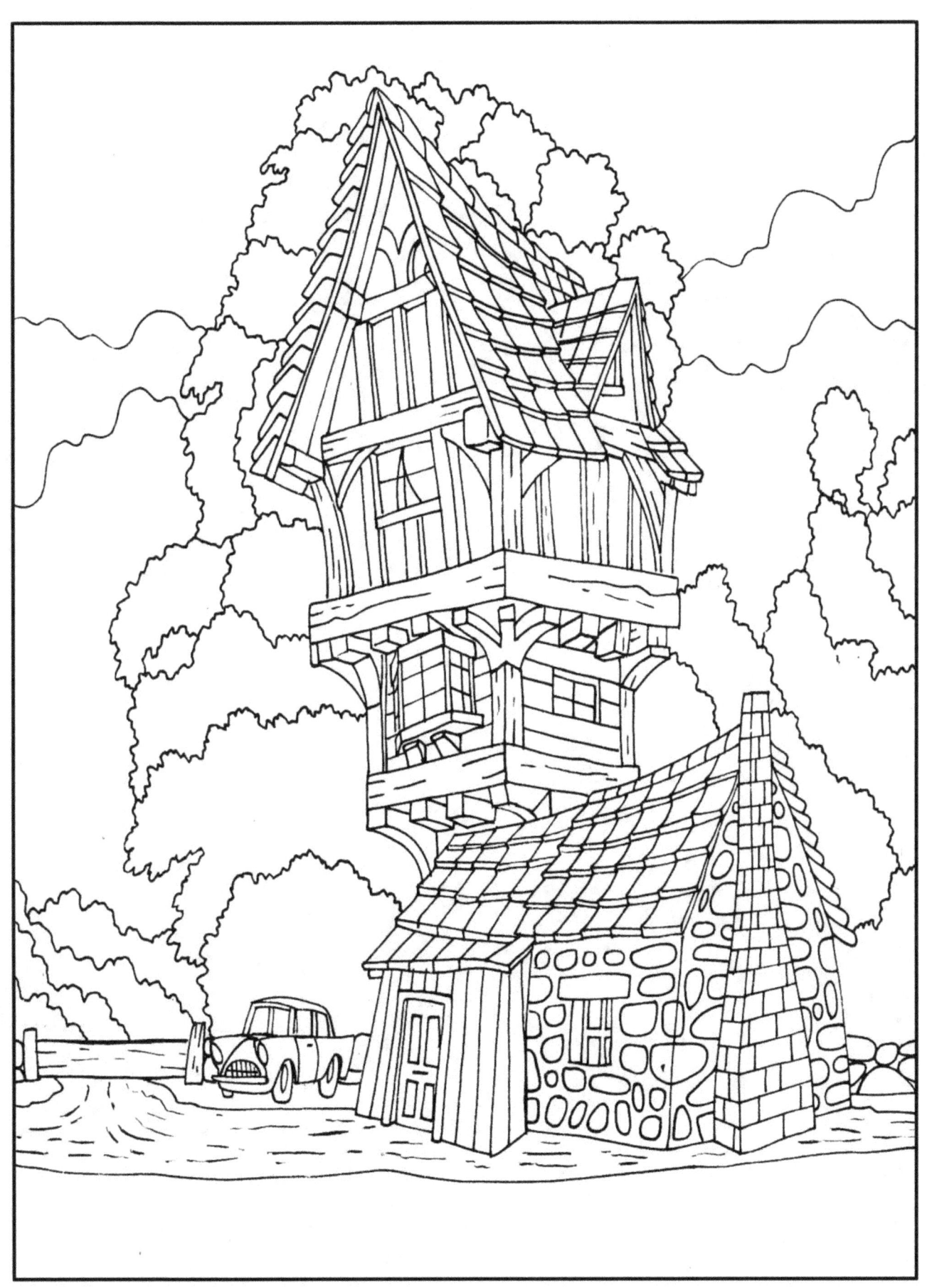

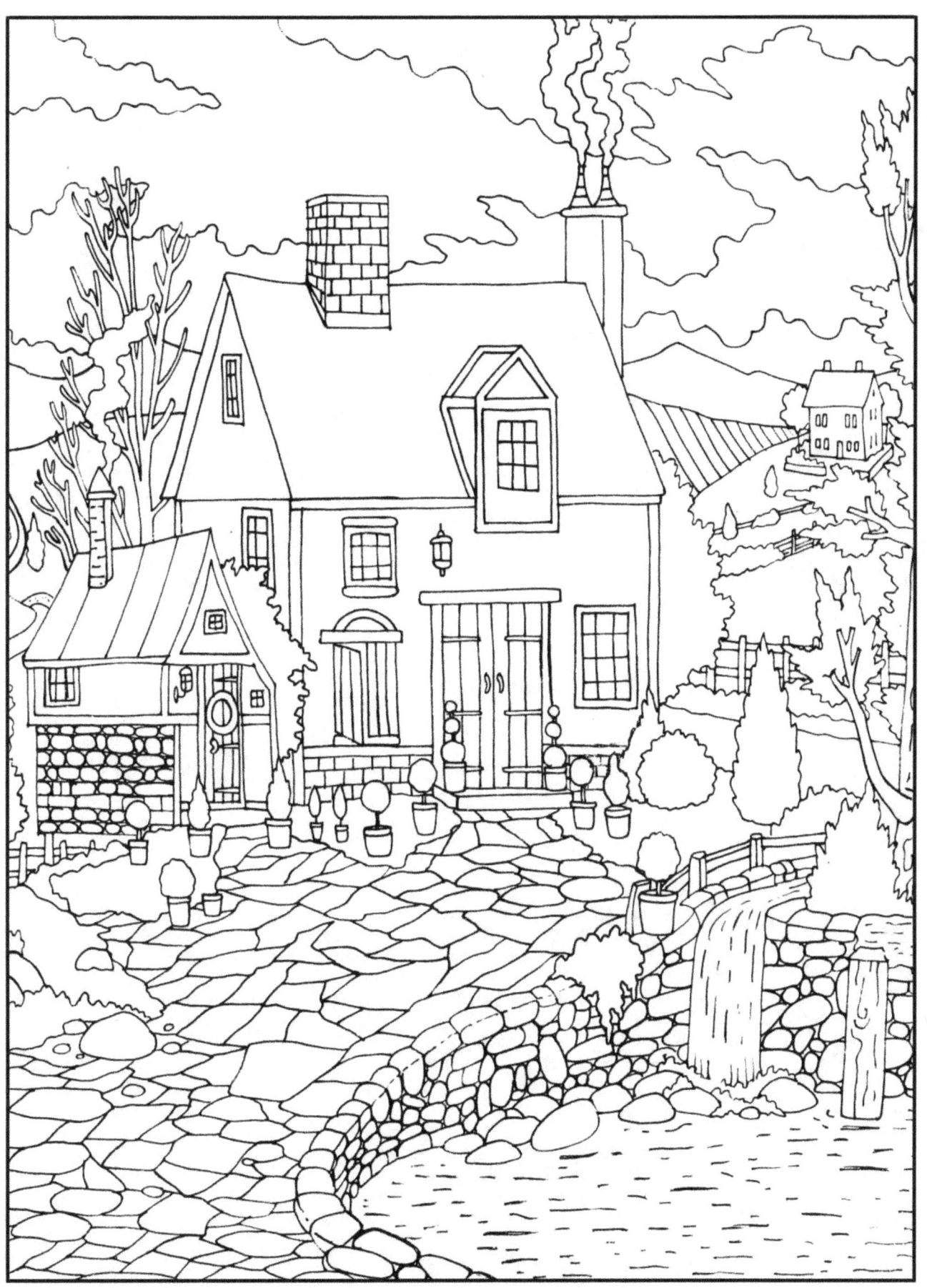

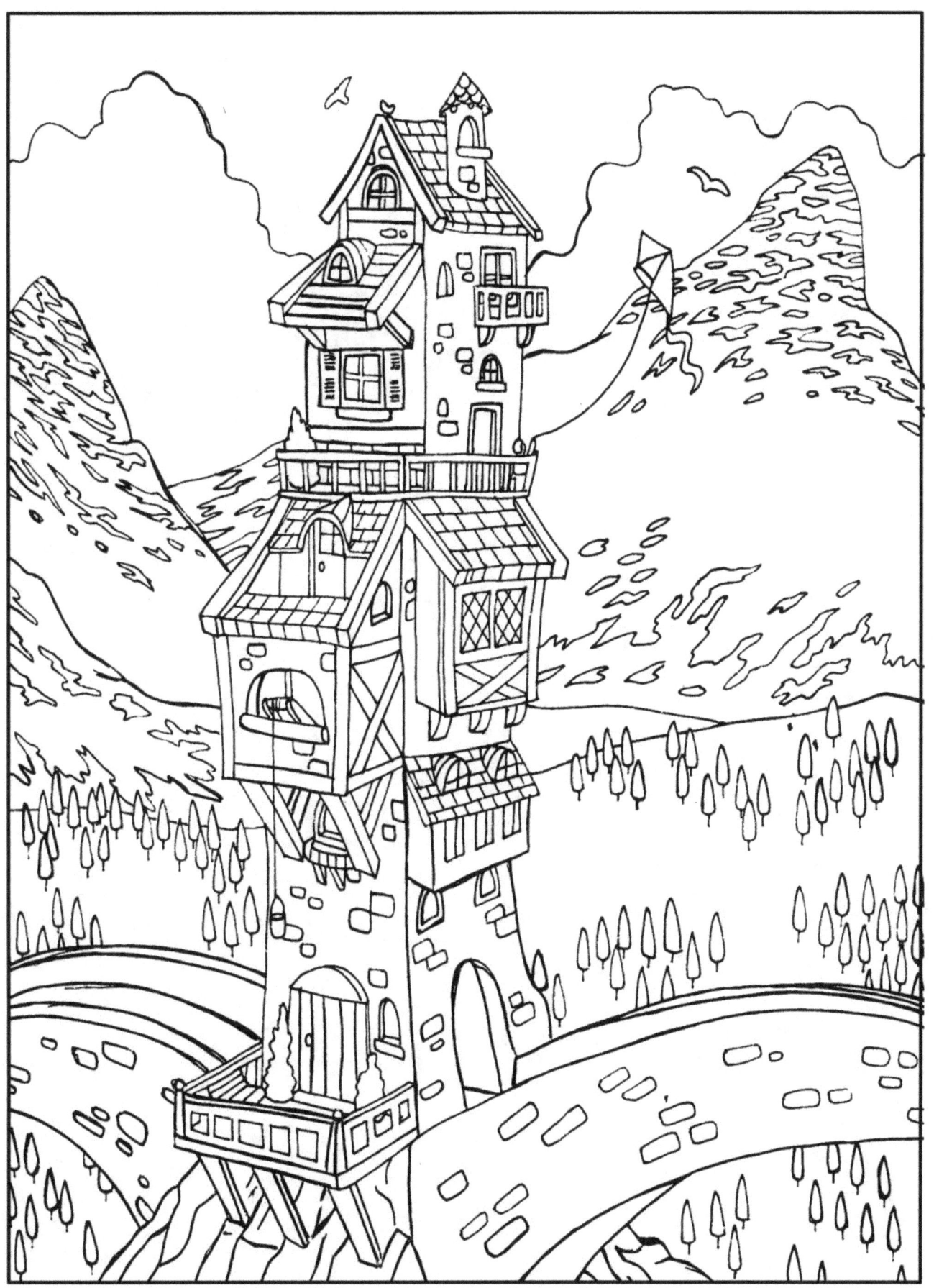

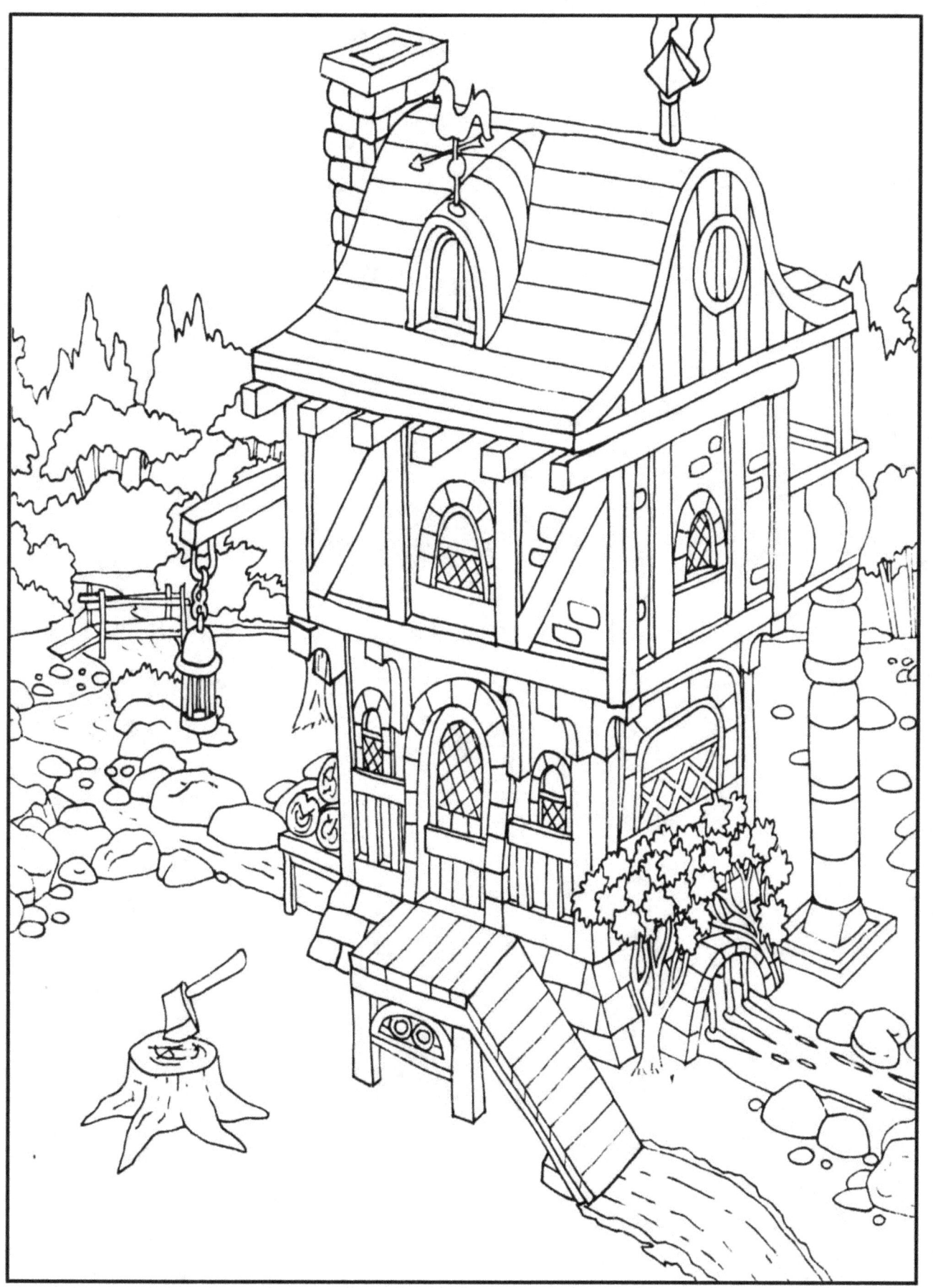

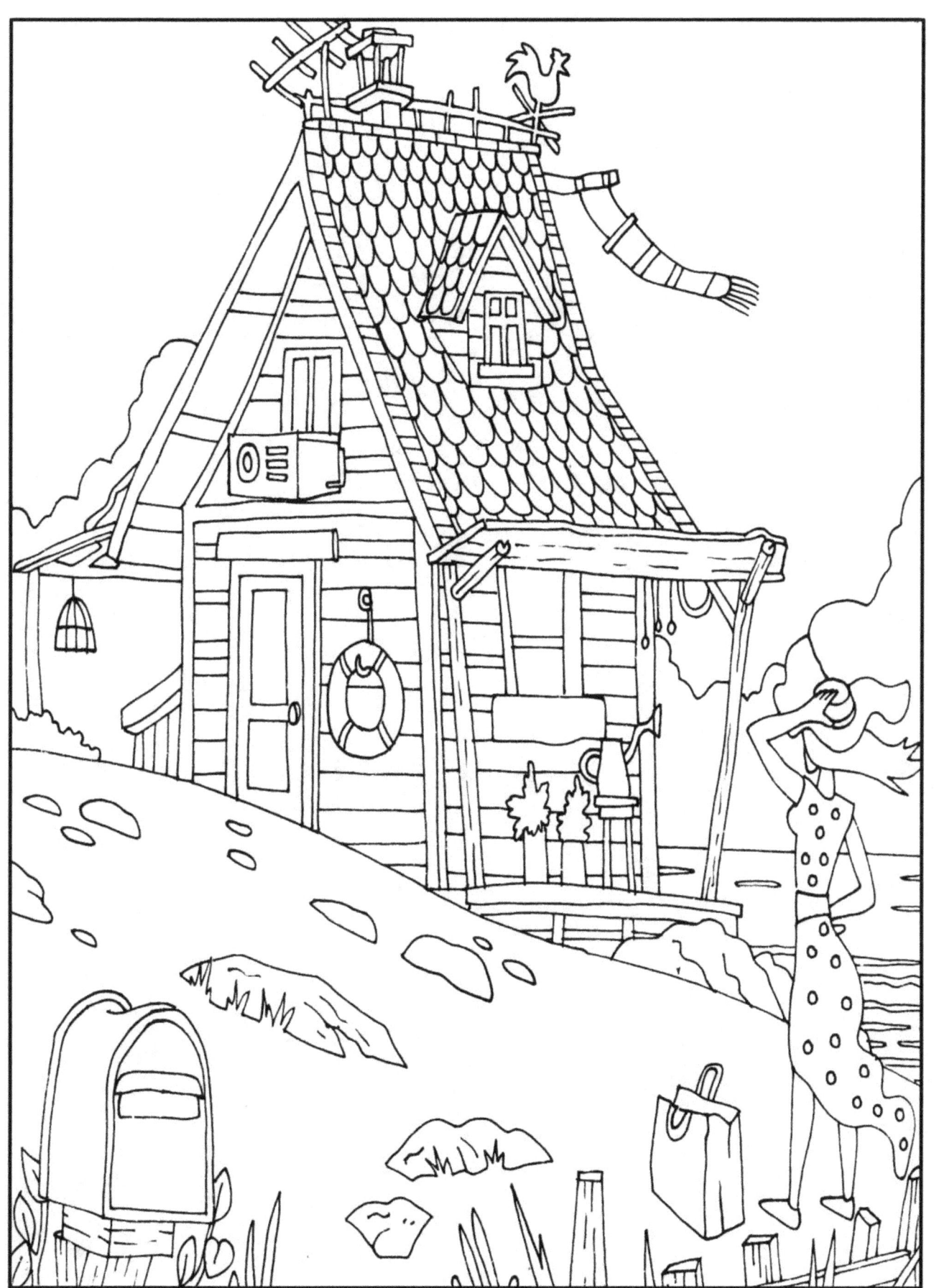

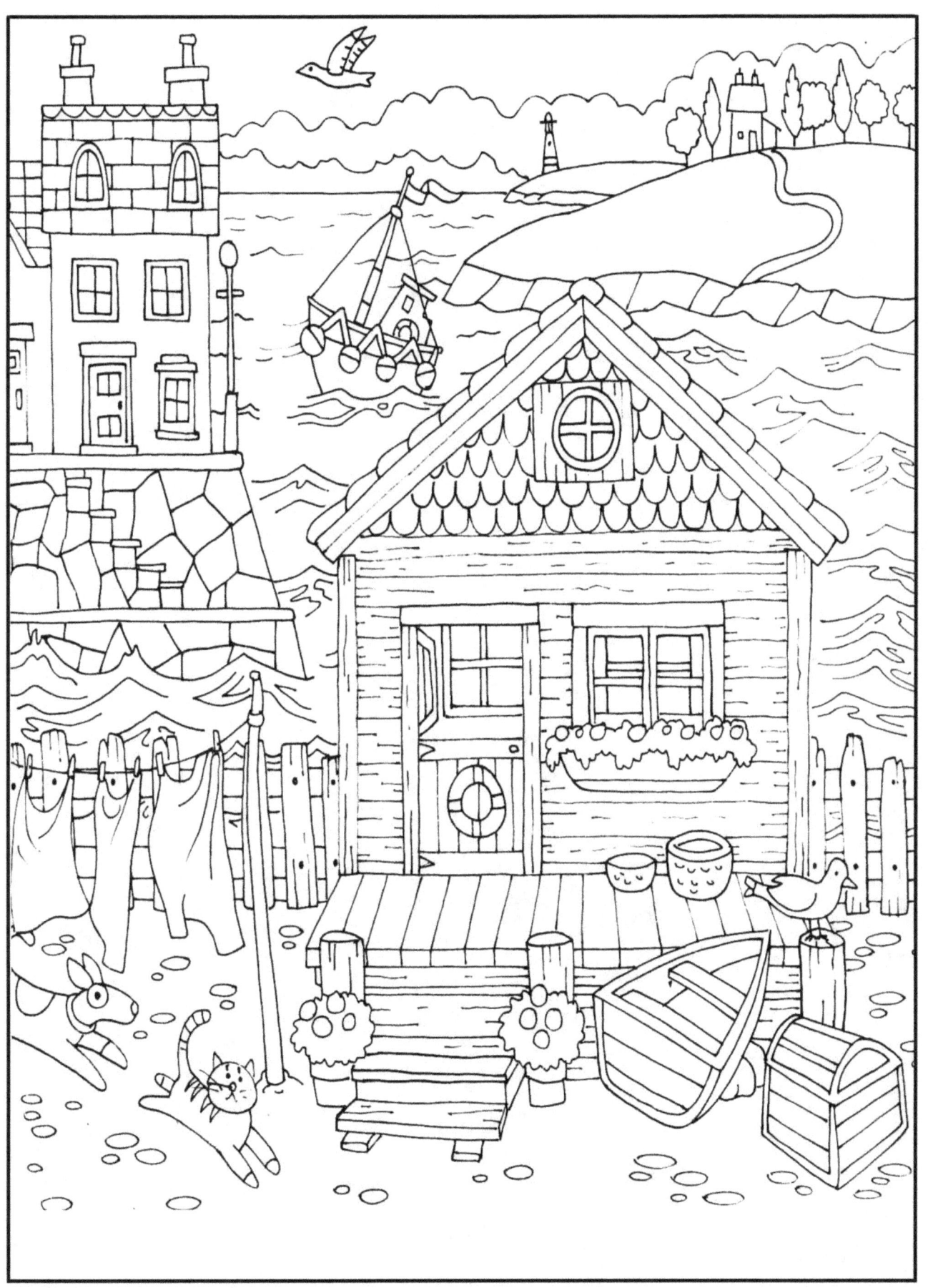

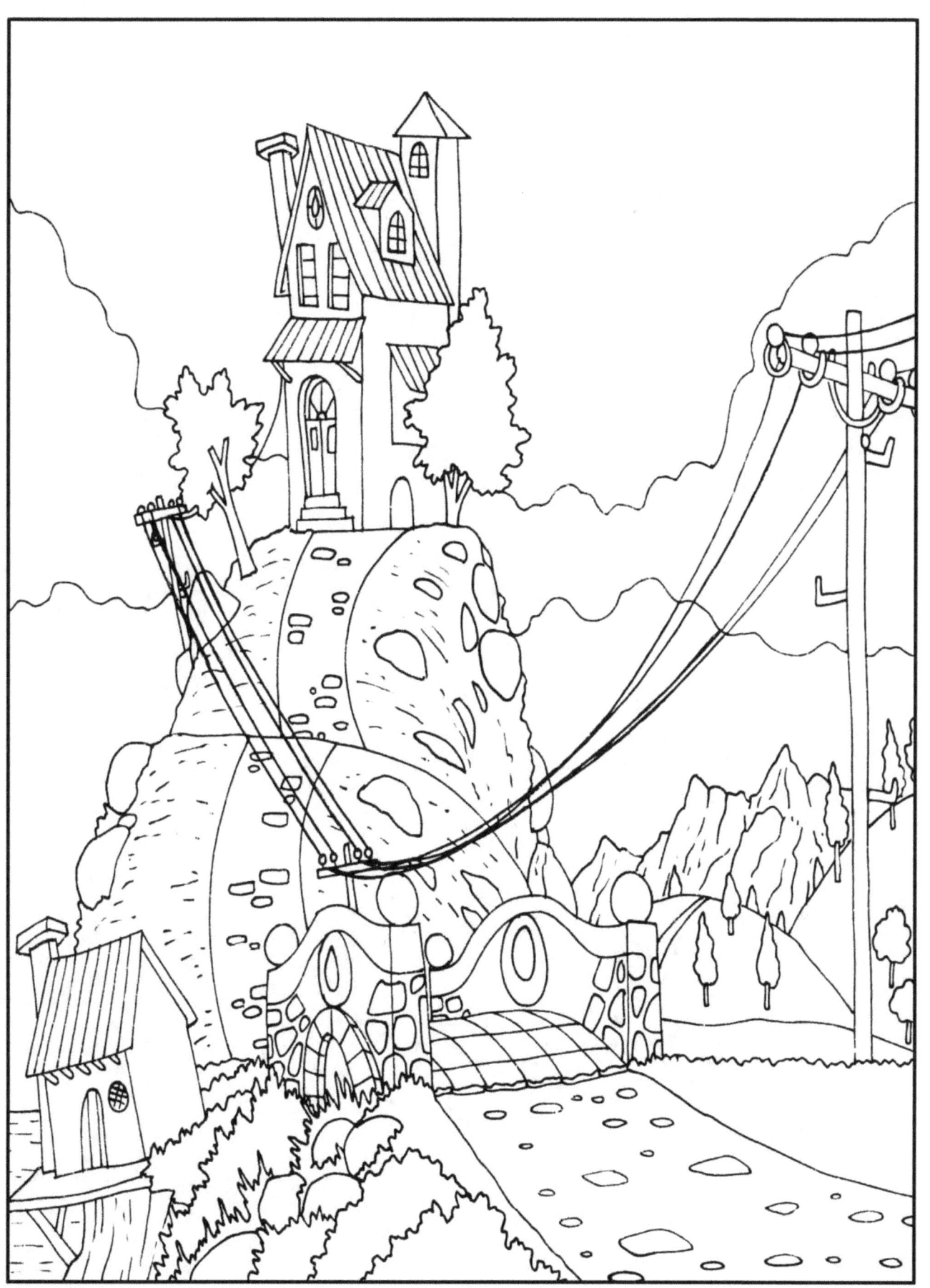

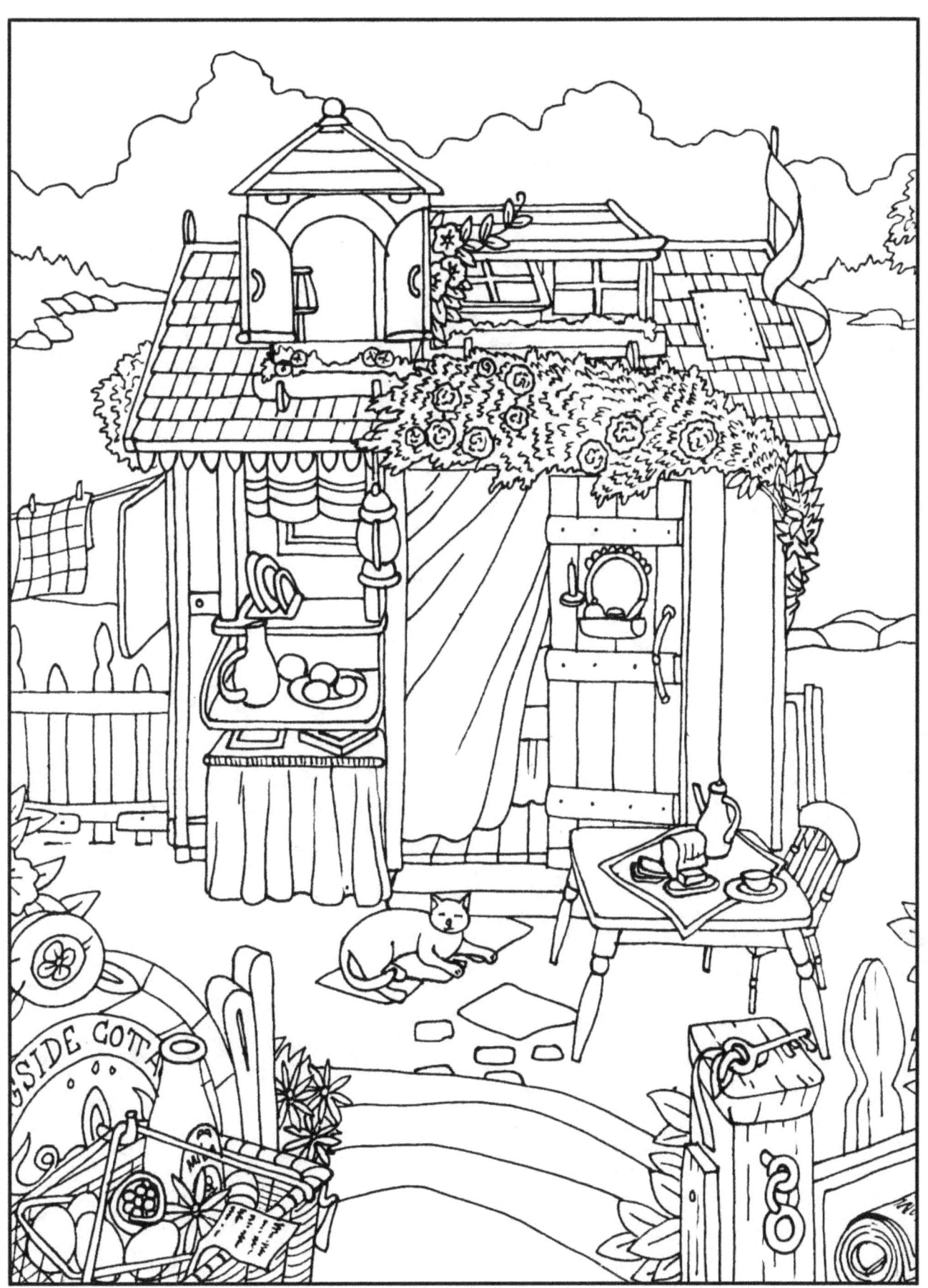

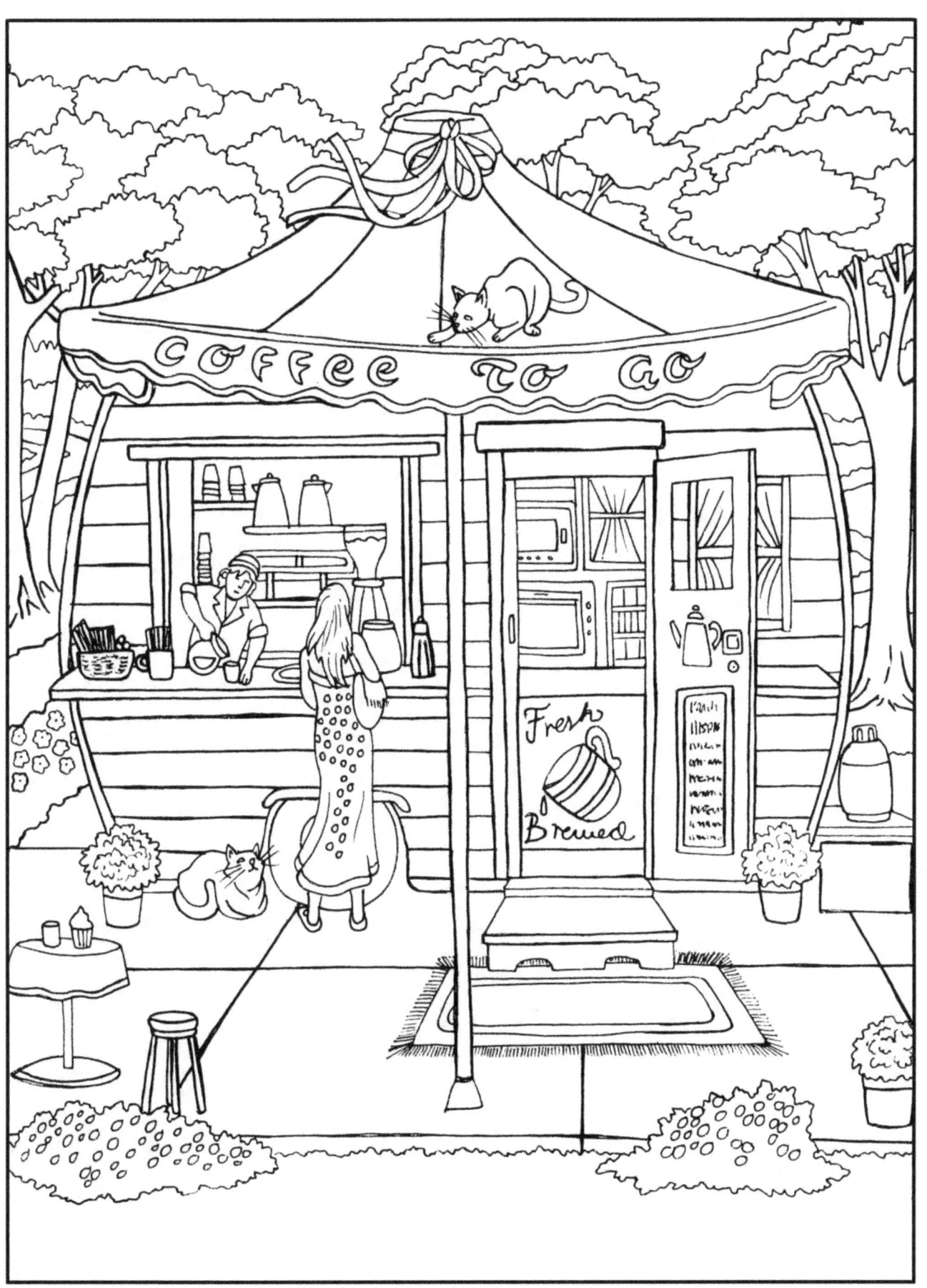

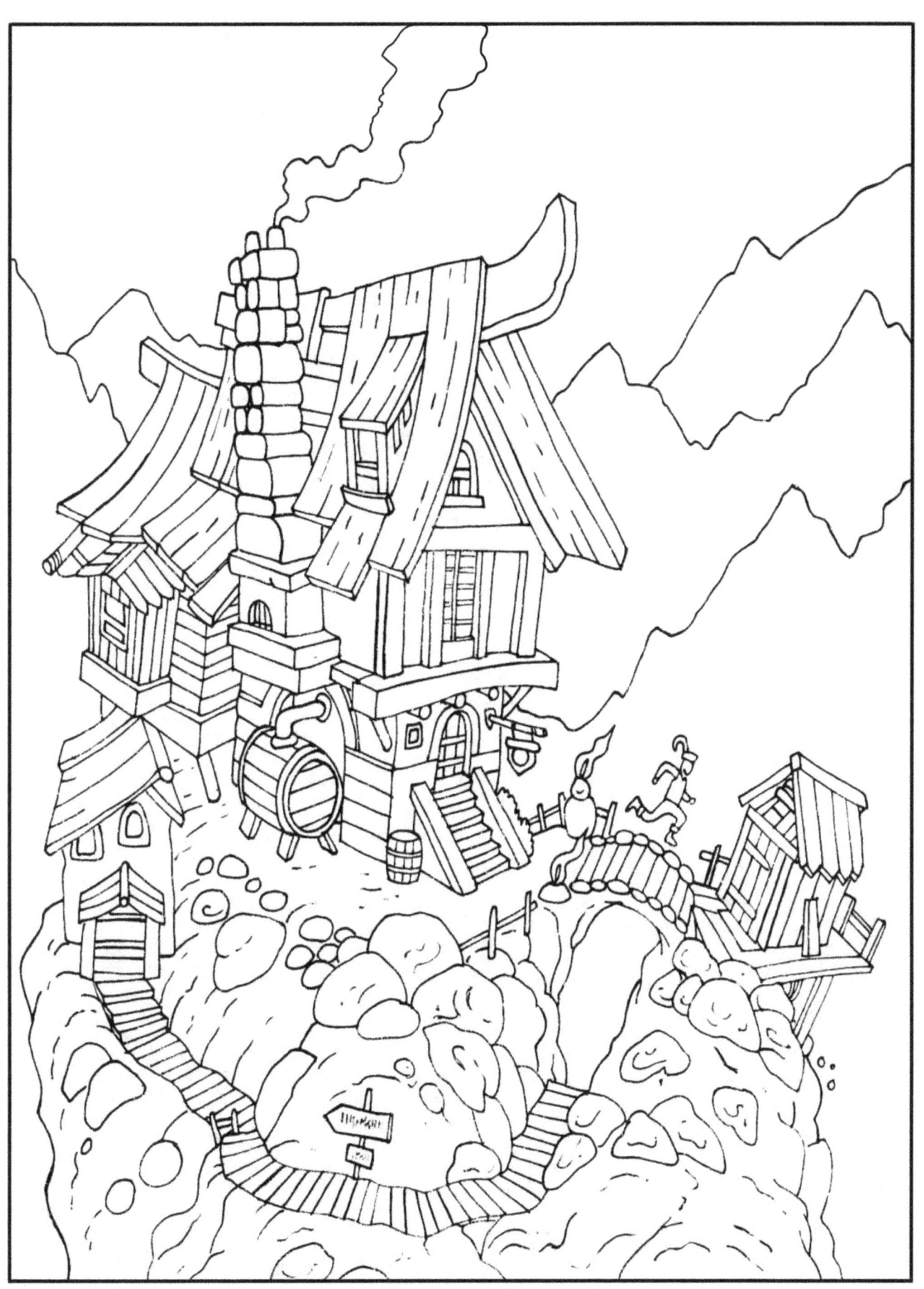

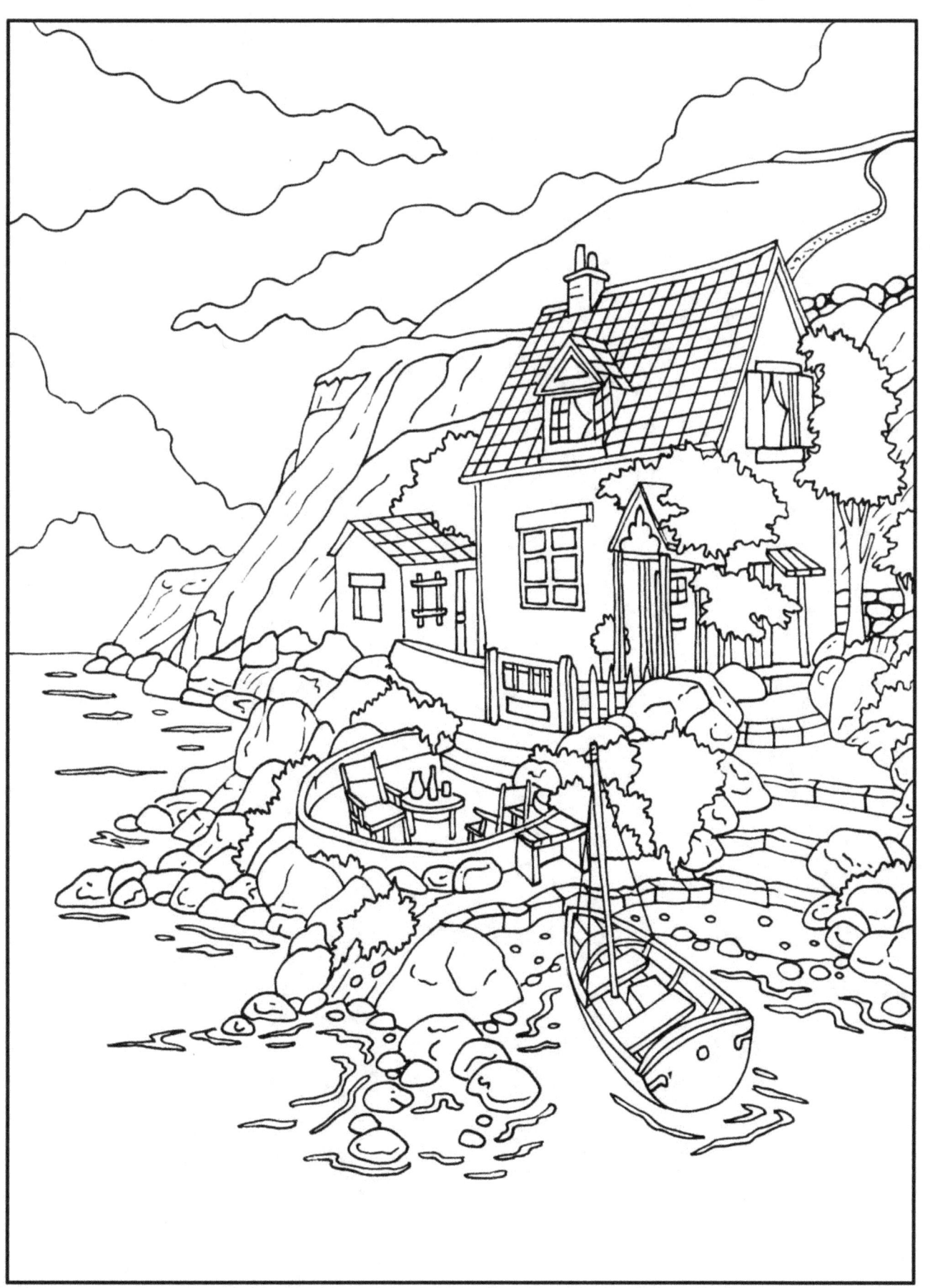

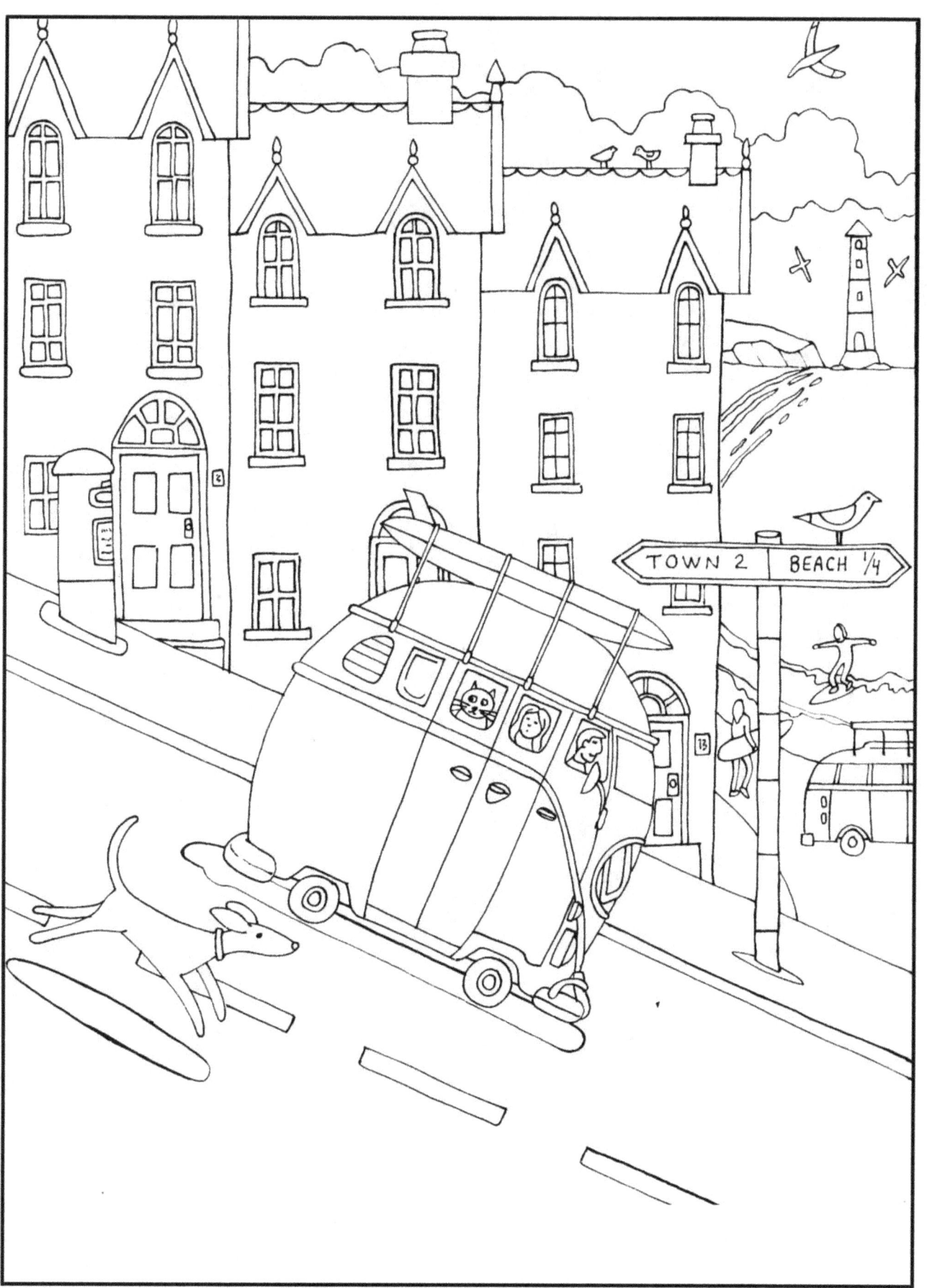

THANKS FOR YOU SUPPORT...SEE YOU SOON!

www.ingramcontent.com/pod-product-compliance
Lightning Source LLC
Chambersburg PA
CBHW081452220526
45466CB00008B/2604